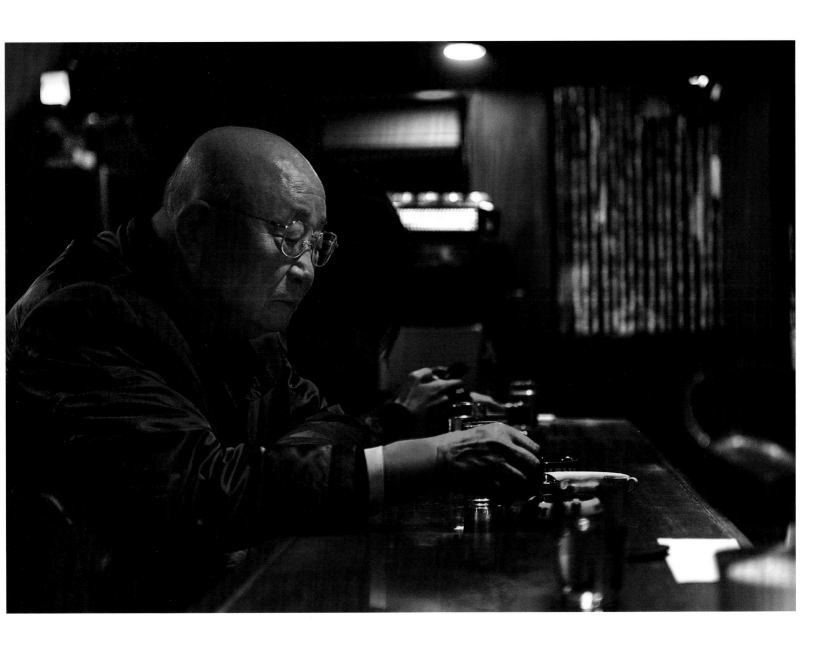

FOREWORD

Laura Pressley

What does it mean to dine alone? What does it mean to dine alone during a pandemic? What is our relationship to solitude in light of technology?

Nancy Scherl's work *Dining Alone: In the Company of Solitude* invites us to consider these questions. The work spans thirty-five years, ending in 2020, providing a new context for isolation brought on by the global health crisis. The images unfold in a cinema verité style, so the camera is used to unveil truths in a documentary approach. The sixty-five plates are a window into trends of fashion and dining establishments over three decades, reminding us that eating alone still involves being seen.

Dining alone in public, particularly for an evening meal, can be discomforting. Restaurants are inherently social, and it can feel as though the lone diner is somewhat less welcome and maybe even antagonistic to the business model. There can even be a perceived or real tension between the solo diner and those having the plural dining experiences, as many restaurants are primarily set up to accommodate groups who tend to eat and spend more. In 2020, expectations shifted due to COVID-19 restrictions; groups were minimized and solo dining was more normalized. However, despite there being evidence of some restaurants and coffee shops that have addressed the solo-diner market, the industry is still coming to terms with the global growth of single households.

Even before the pandemic, eating alone was on the rise as single-person households were also increasing. A 1999 survey found that the number of people who ate alone tripled between the 1960s and 1990s. By 2006, nearly sixty percent of Americans regularly ate on their own. In addition, a 2015 survey from OpenTable showed that online reservations for single diners increased sixty-two percent in the United States. Not only a reflection of the changing eating habits but of global lifestyle trends, Tokyo's Research Institute concluded that by 2020 living alone would be the norm in Japan. That is not just in Japan: according to a US study, single-person households are expected to be the fastest-growing household profile globally between 2014 and 2030.

The existing structure of most restaurants allowed for the continuity of the stigma associated with eating alone, reinforcing that it is in some way deviant, rather than an opportunity for an experience of solitude. Generally speaking, solitude remains a controversial concept not sought out by many people. Some find the experience stressful and threatening while others find solitude refreshing. Often wrongly equated with isolation and loneliness, it is alternately praised to spark creativity and psychological growth. In 2009, Yale University professor William Deresiewicz discussed in his influential essay "The End of Solitude" how due to technology we live exclusively in relation to others, and what disappears from our lives is solitude. Technology impacts our privacy, our concentration, and also the ability to be alone, while at the same time, increases feelings of loneliness.

Anthony Storr's landmark text *Solitude* conveys that there are two competing human drives: one for companionship and love, and the other for independence and autonomy. Both are equally important for a fulfilled life. *Dining Alone: In the Company of Solitude* draws attention to the disillusion of the stigma of eating alone. The book invites us to explore the evolving human condition of the individual and the diminishing deference, yet need, for the company of solitude.

Laura Wzorek Pressley
March 2021

PART I:
Universal and Timeless

Nancy A. Scherl

Dining Alone: In the Company of Solitude highlights the experience of being alone while dining in public. We all experience the alone emotions at some or many times in our lives. This work considers how the solitary diner experiences dining in public within the complex meaning of being alone.

The public space of the restaurant setting provides a unique backdrop to imagine a person's private emotions and thoughts when alone in the intimate space of dining. What difference might environment make in a lone diner's feelings and outlook under the cool fluorescent light of a fast food restaurant or in a warmly lit restaurant with charming decor as others chat quietly together over a meal? Being alone while dining probably does not diminish the range of emotions a person feels, but personal emotions are often obscured in the crowds, activities, and ambience of a restaurant.

The imagery in this series suggests that the presence or absence of others, as well as the dining ambience, may affect the diner's mood. Lone diners are both observer and observed—how often, and when, does the diner shift between these points of view? The immediacy of being alone in public creates a natural dynamic contrast between the basic human need to connect and the necessity of confronting oneself as alone in life, in at least that moment. Dining alone for a woman or man is likely a meaningfully different reality. Age, race, culture, the country where one is dining, and one's personal life circumstances necessarily have a bearing on the quality of experience when dining alone.

A passer-by might wonder, what is this person feeling? Who is she and why is she alone? Does she want to be alone? Would he want to share his feelings with a stranger, or does he prefer to remain isolated, disconnected, or even anonymous?

Does it take courage to sit and eat alone? Does a cultural or generational stigma about eating alone in public affect the lone diner's experience? Or is the diner content and confident being alone while eating in public? Which emotions are shared with others and which are private when eating in public alone? Where on the nearly invisible spectrum of emotions might a lone diner be experiencing the moment—is it closer to loneliness or to solitude?

Whether the diner in these photographs is seated apart from others or seated next to or among others, the viewer of these images participates in exploring and interpreting feelings and events both within and outside the visual frame. Focusing on the lone diner, regardless of environment, what is unseen about the diner is as important as what is seen. How a viewer interprets what they see will include reflections of their own experience, culture, and generation. Nevertheless, images in this work suggest a more universal experience of being alone, one that extends beyond time, place, and the presence or absence of others.

When does being alone in any environment become the estrangement of anonymity or feeling lonely, and when is being alone solitude, bringing pleasure or the fullness of joy? Cultural shifts over time and generations have changed the acceptability of being alone in public, slowly erasing stigmas that are dismissive and contribute to a person being or feeling invisible. One can hope that enjoying solitude will overtake loneliness in our public alone times. Still, loneliness and alienation when experienced privately are often invisible. Each diner in *Dining Alone* invites viewers to indulge in considering different points of view.

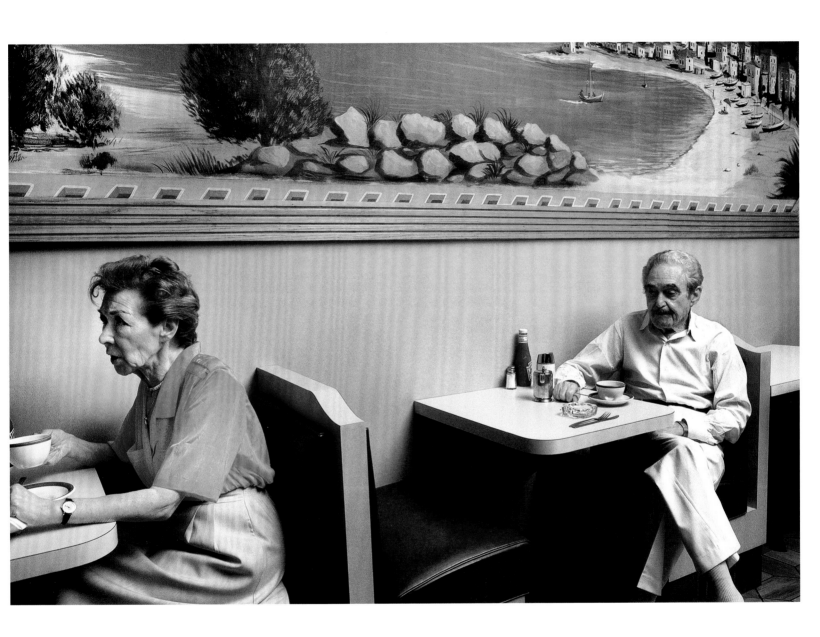

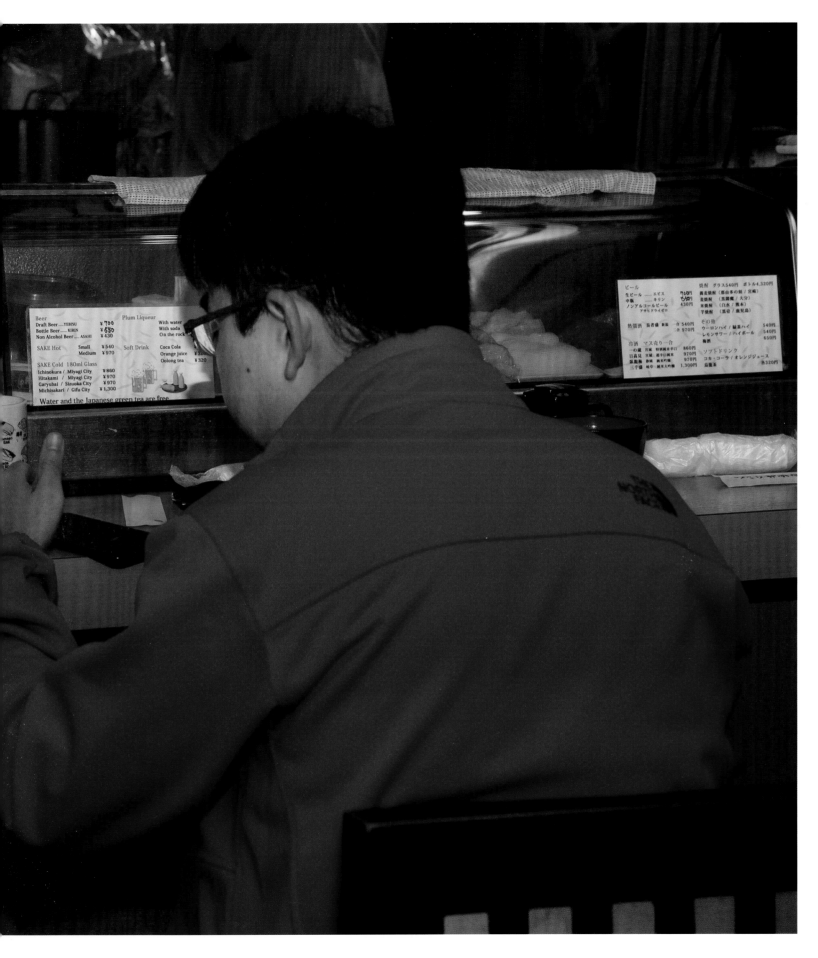

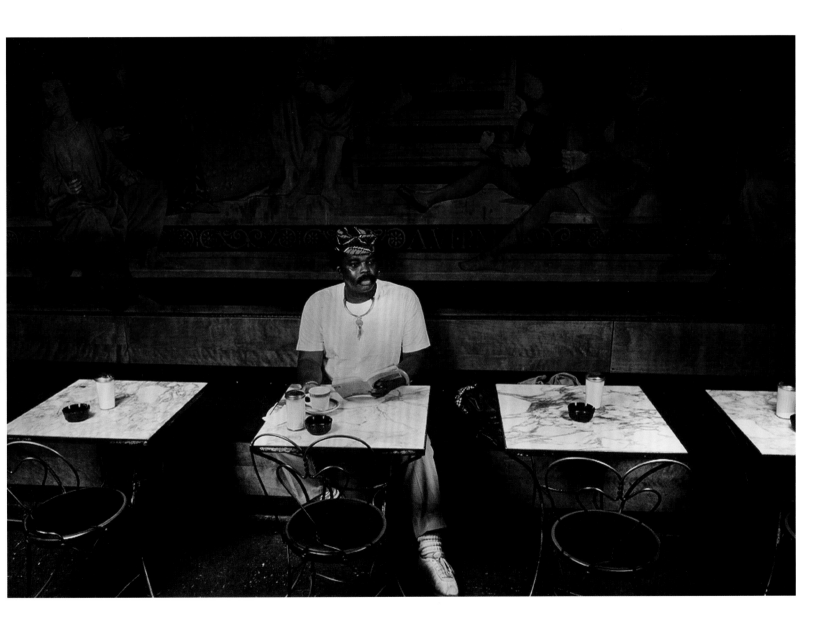

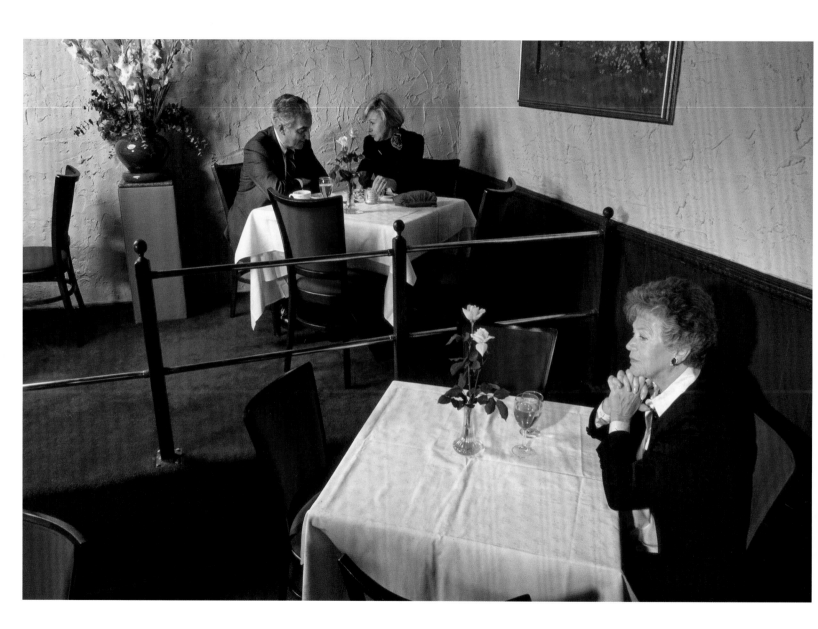

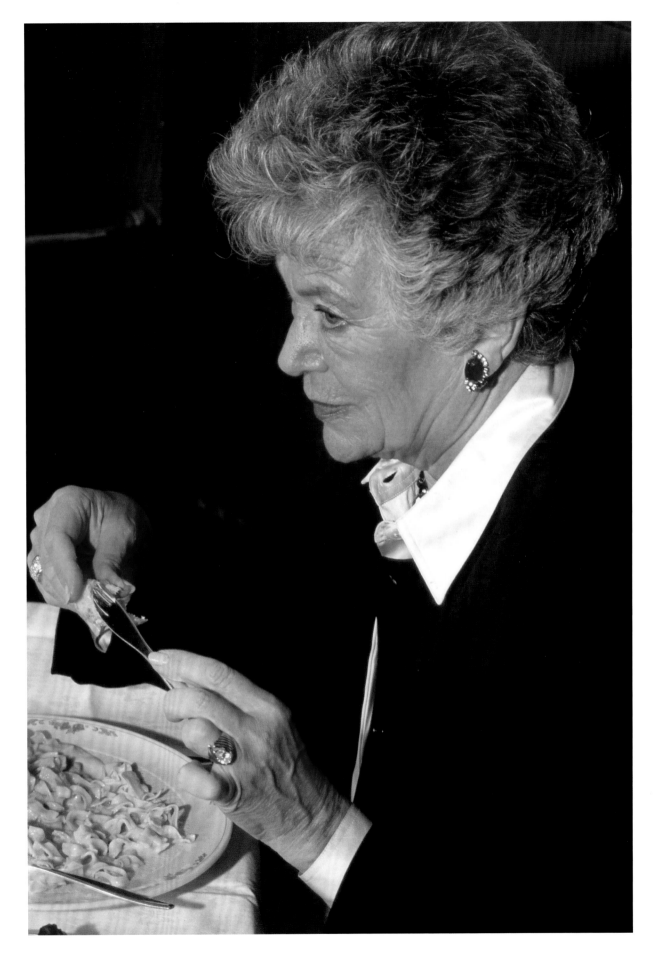

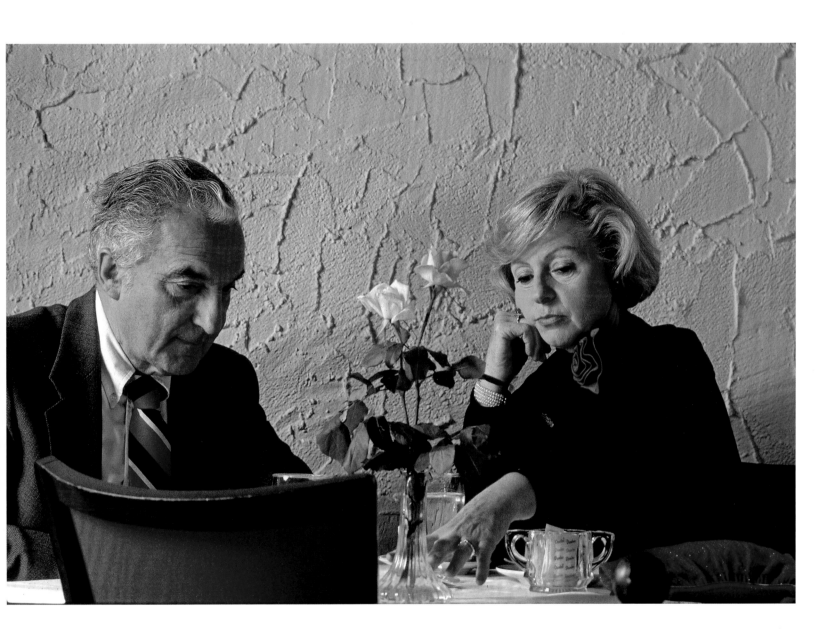

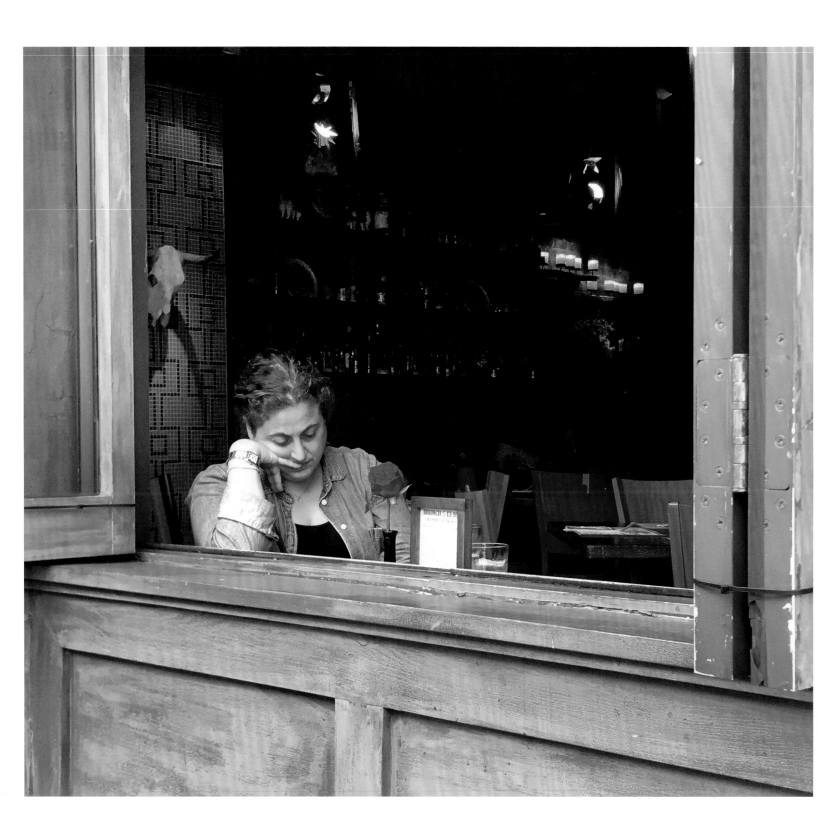

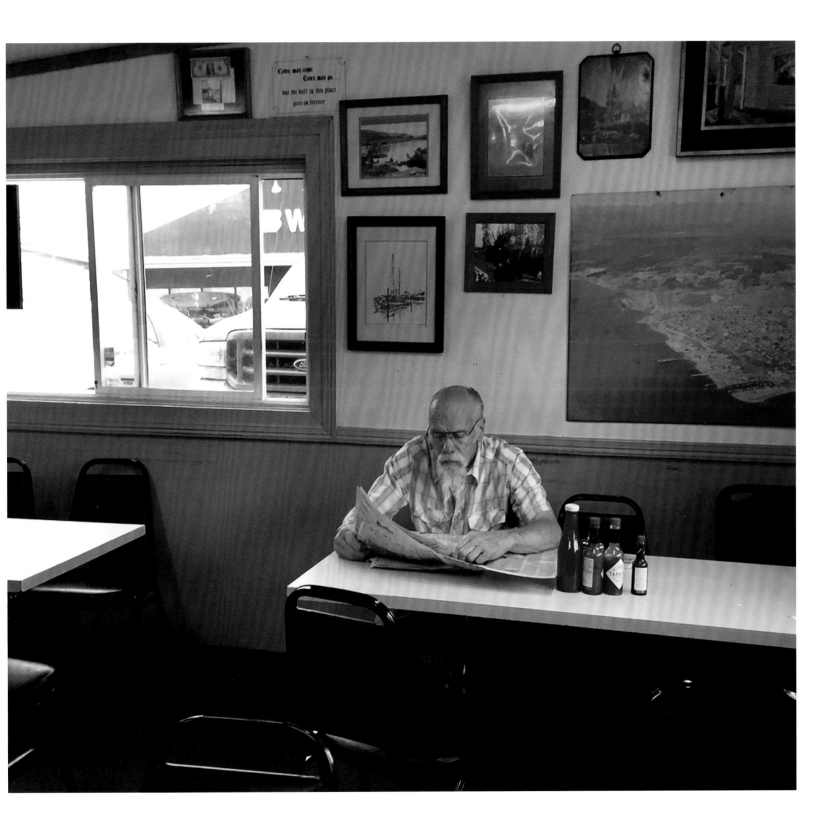

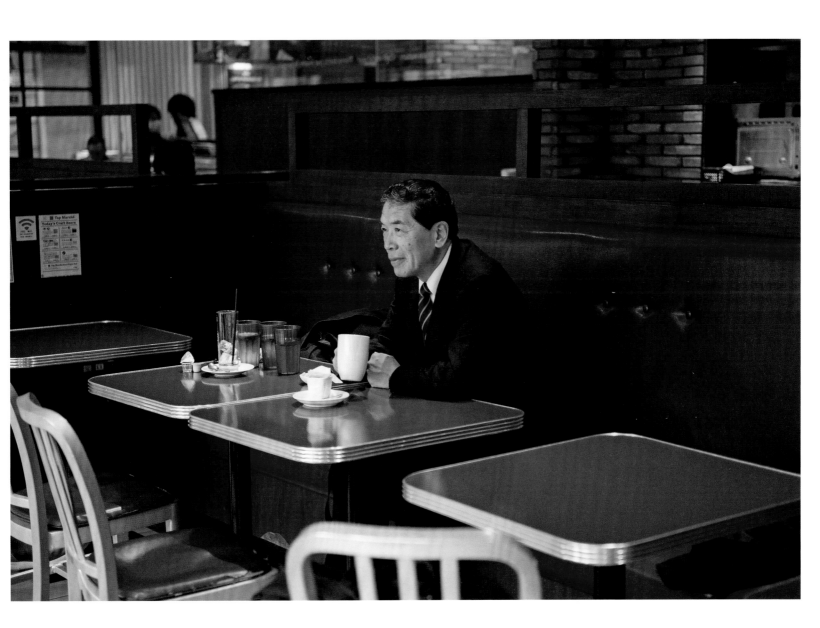

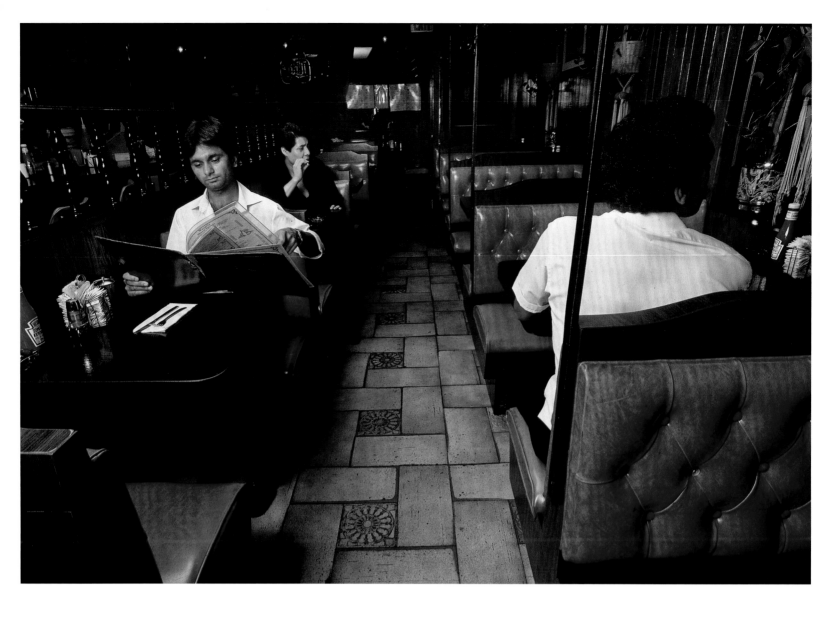

no. 11
—

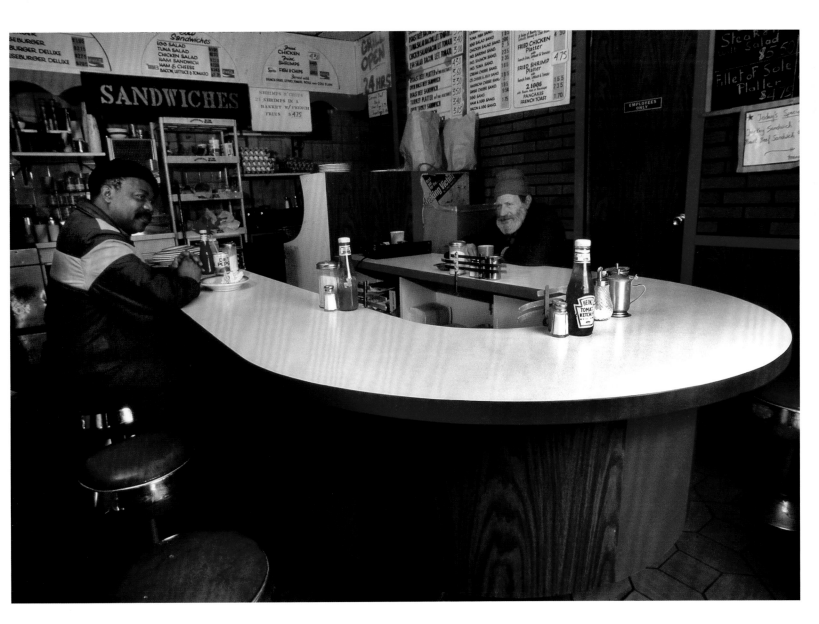

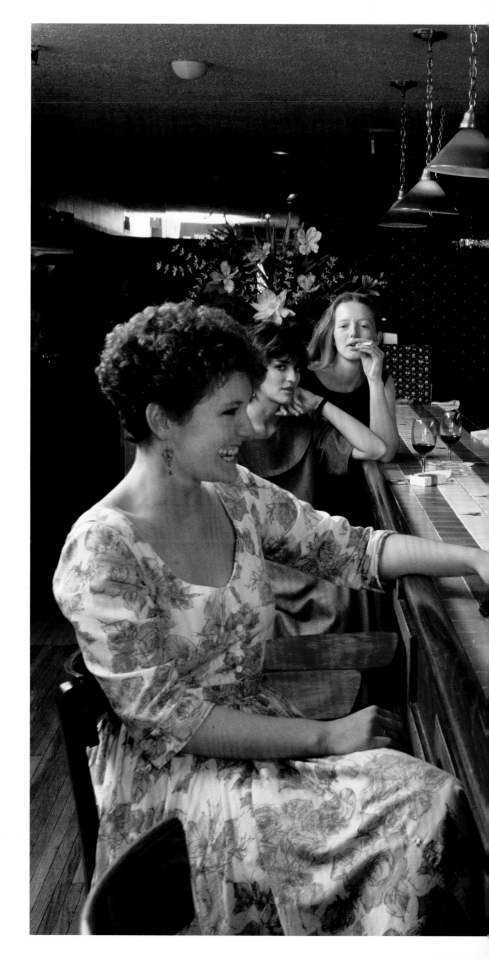

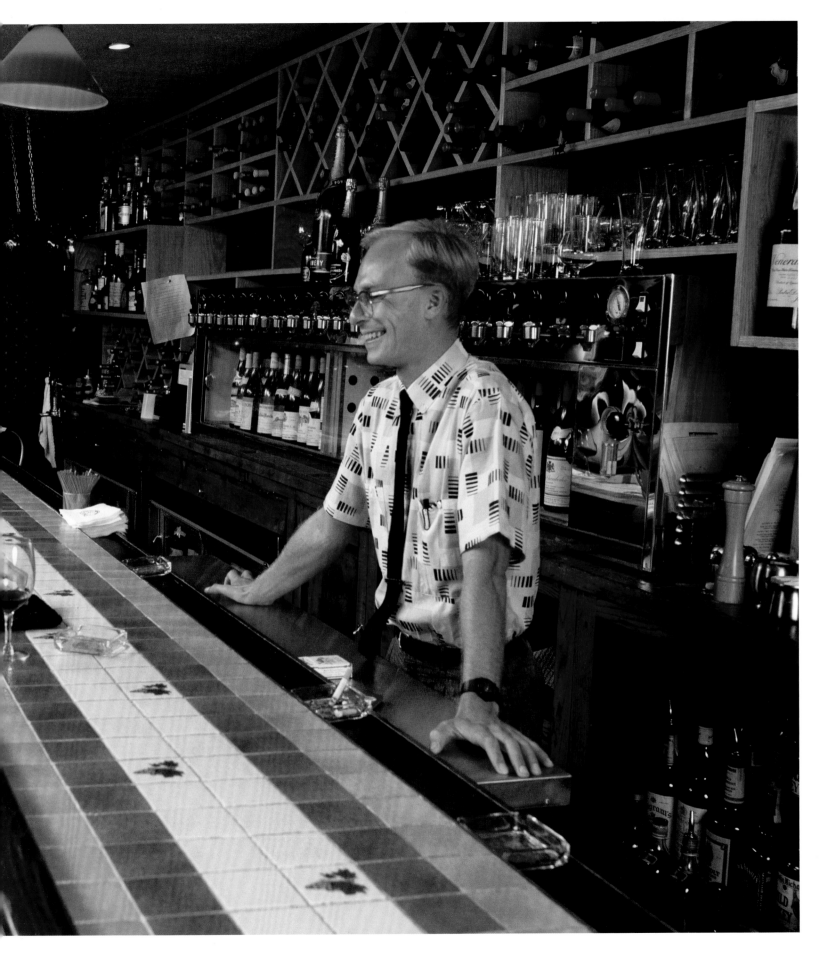

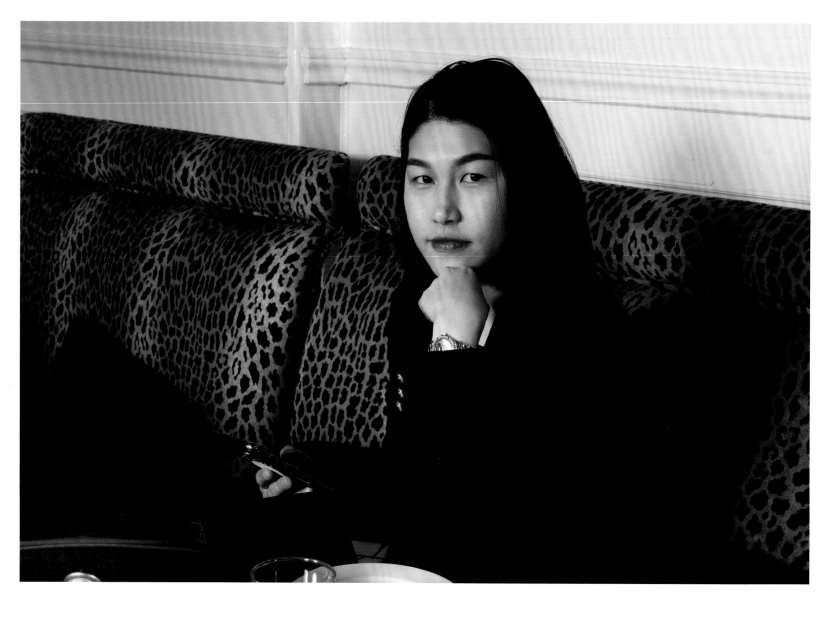

no. 14
—

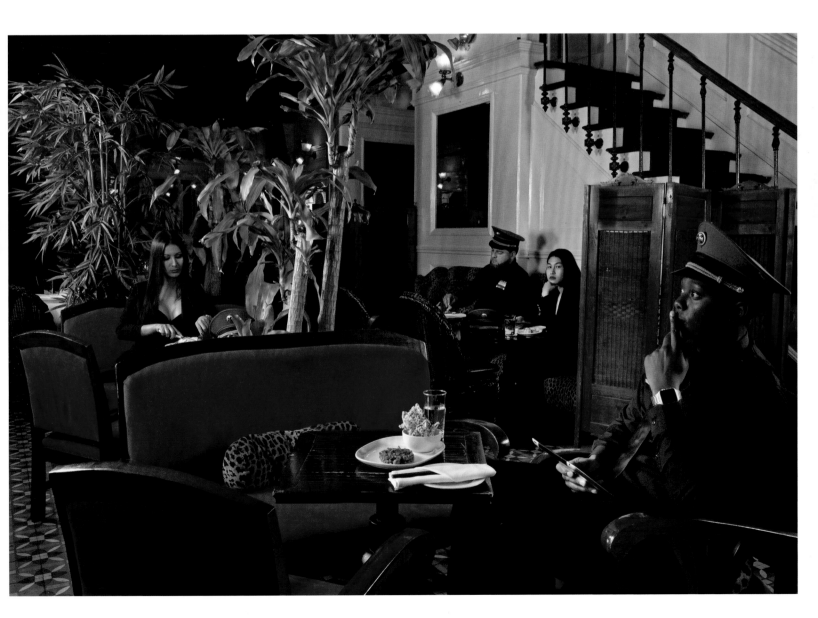

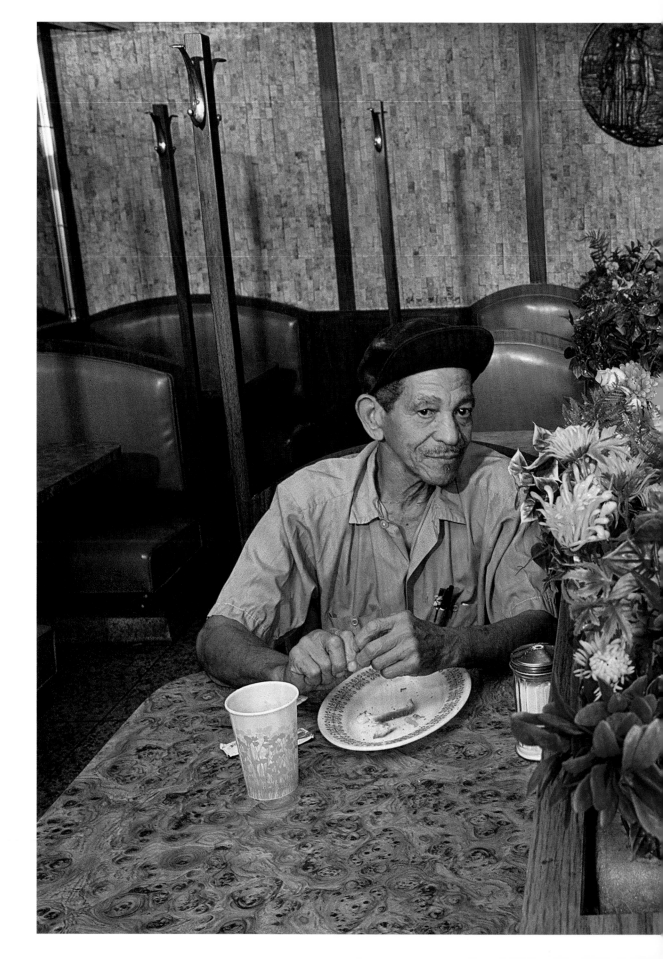

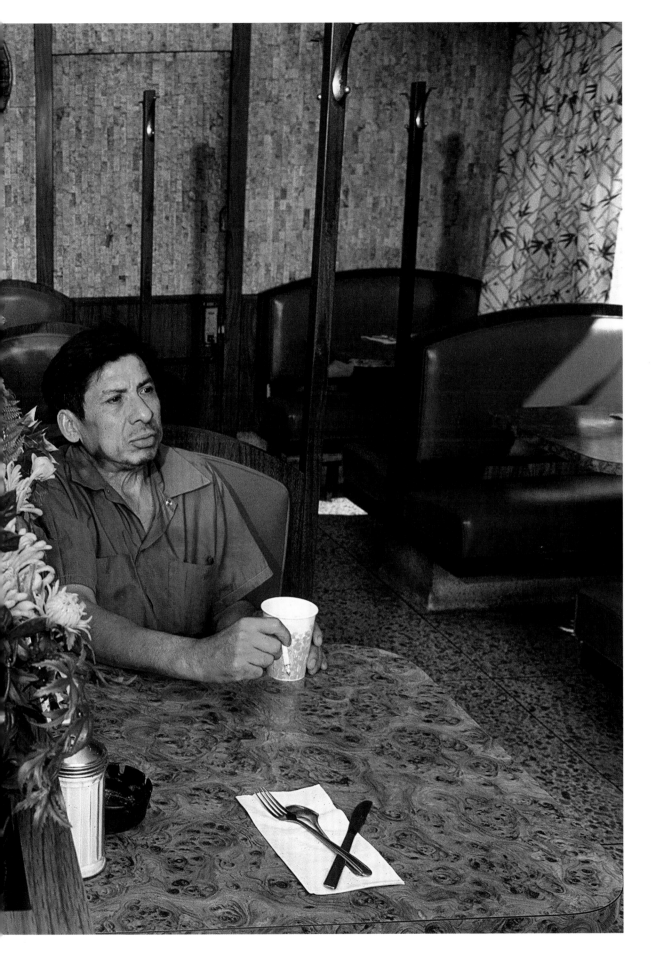

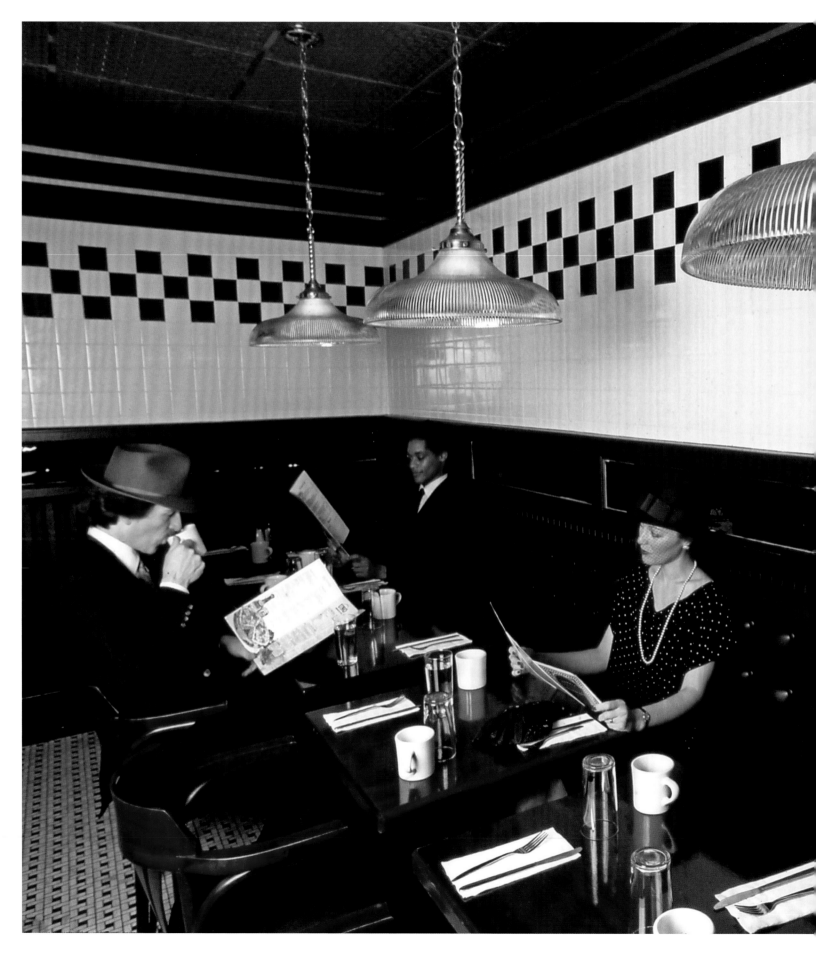

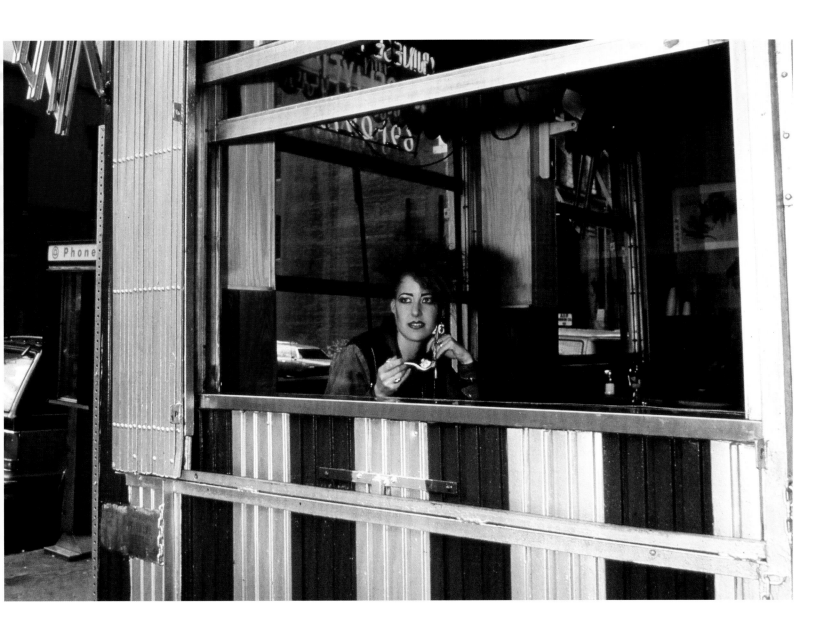

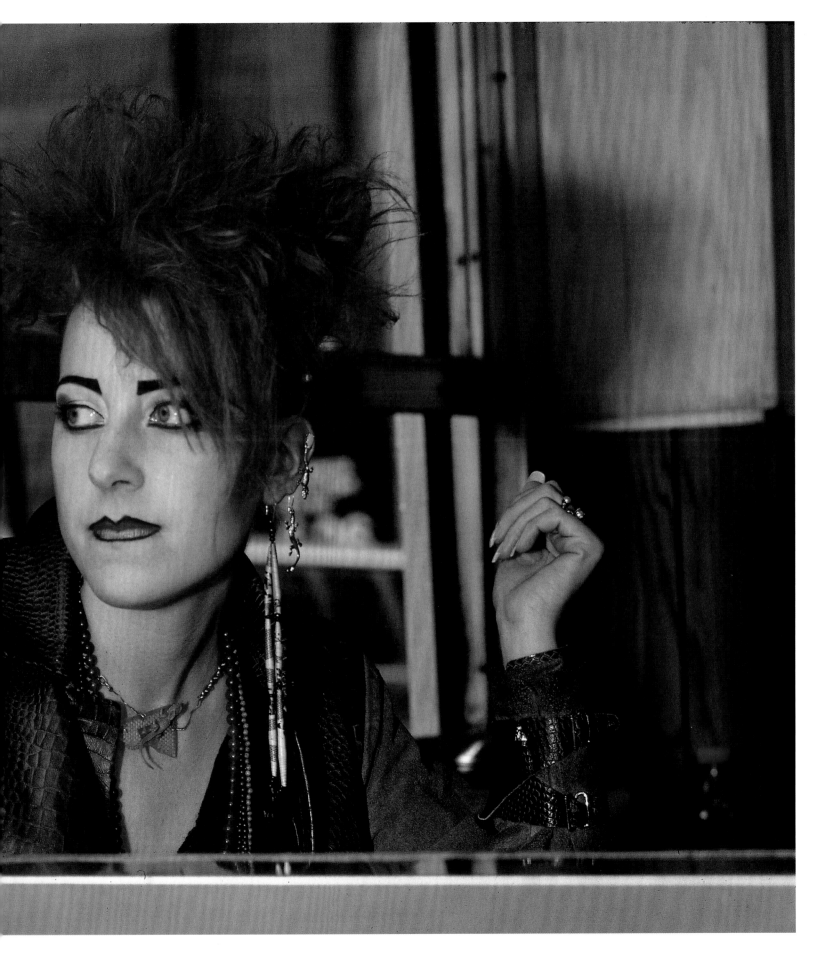

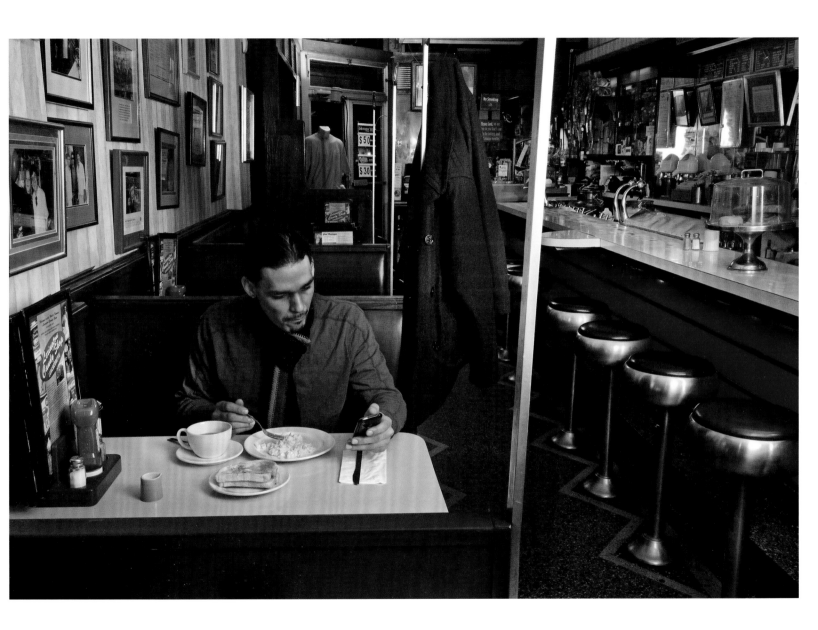

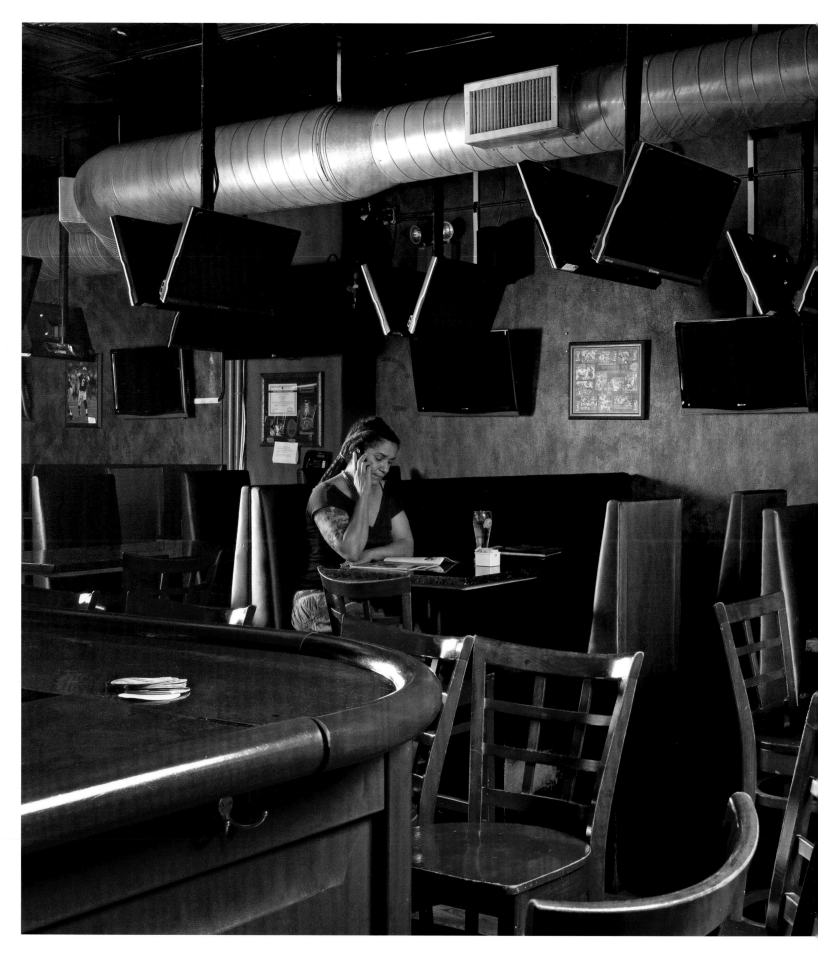

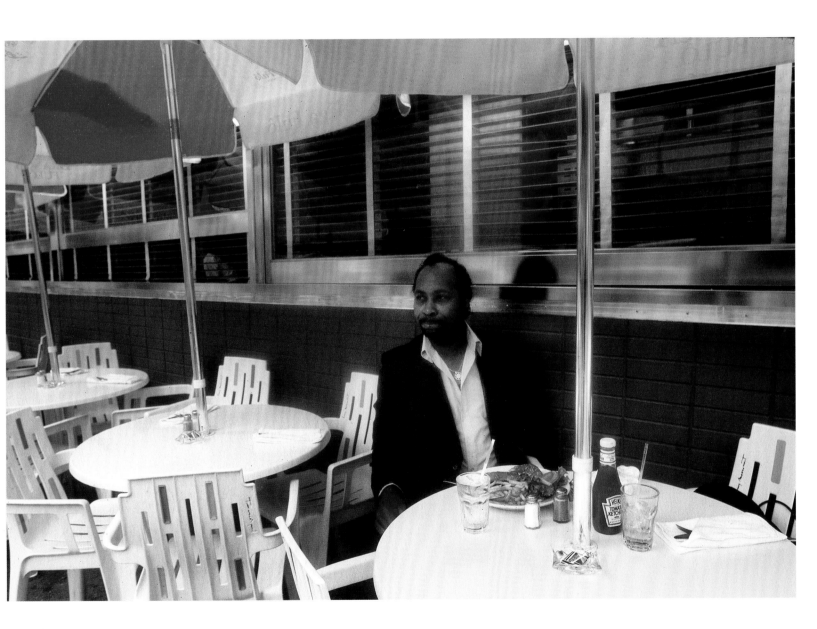

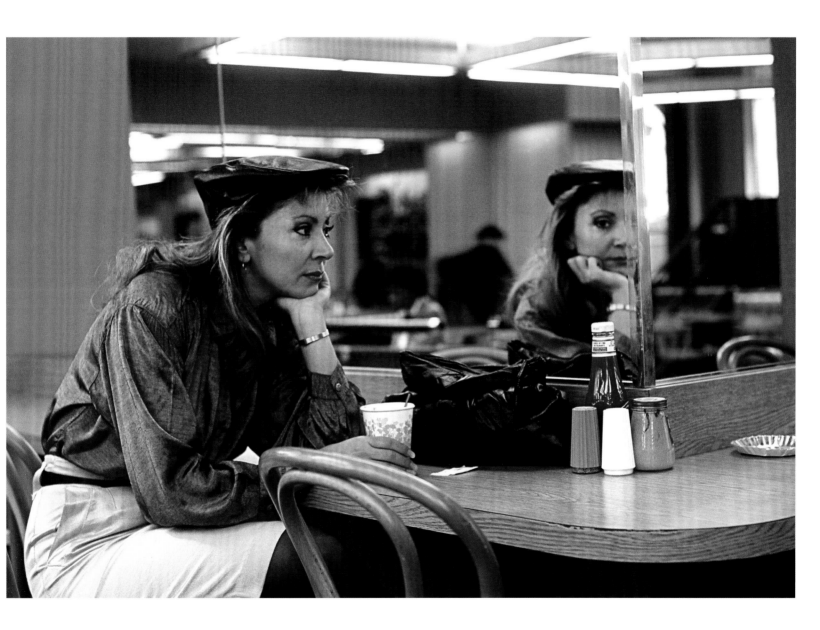

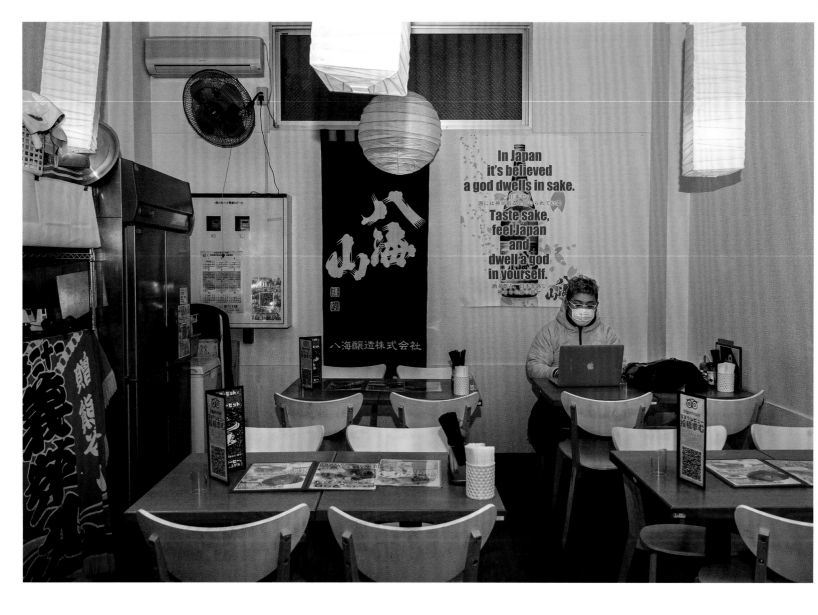

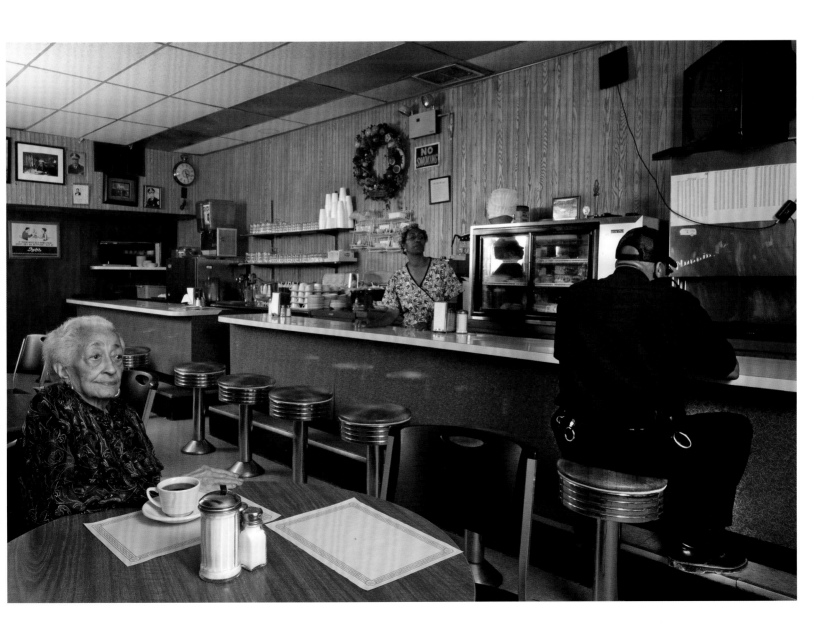

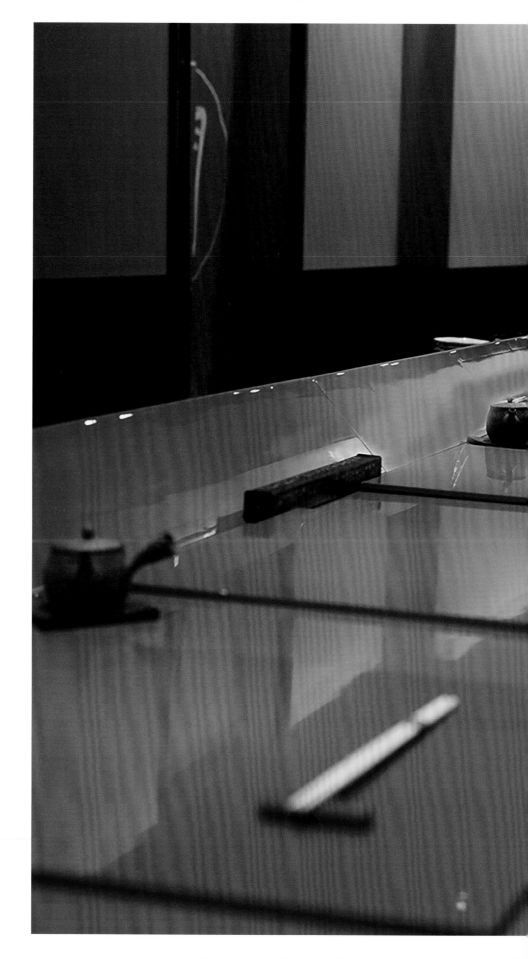

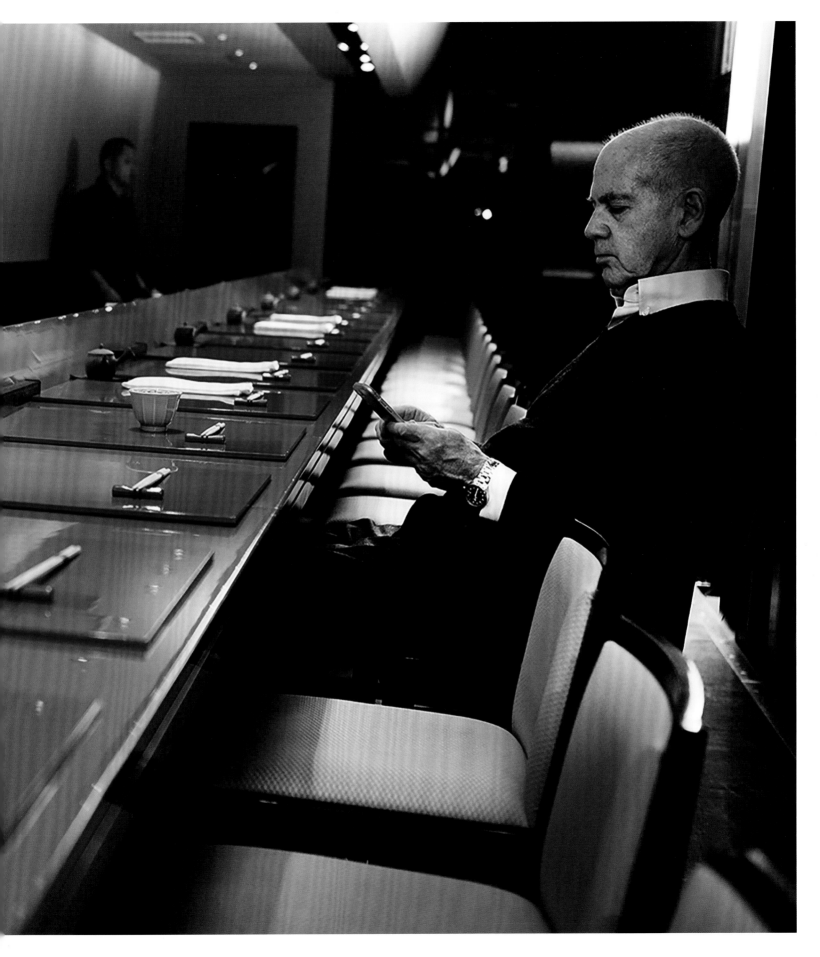

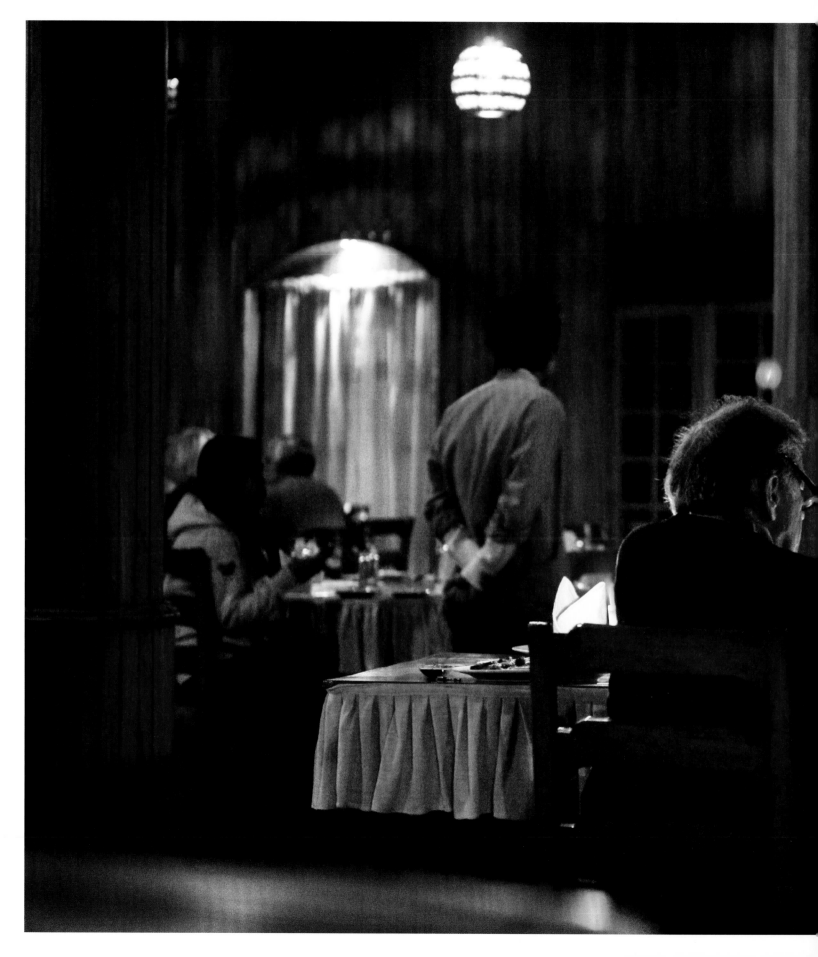

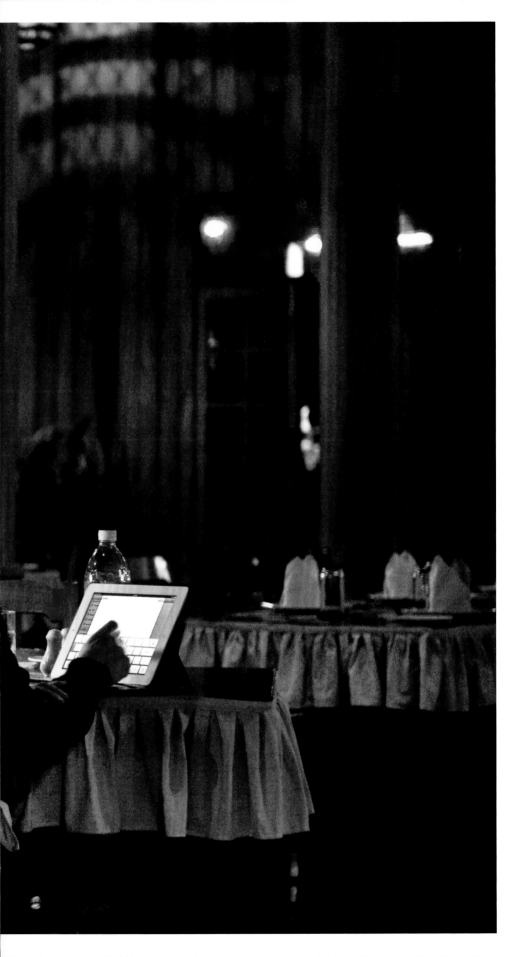

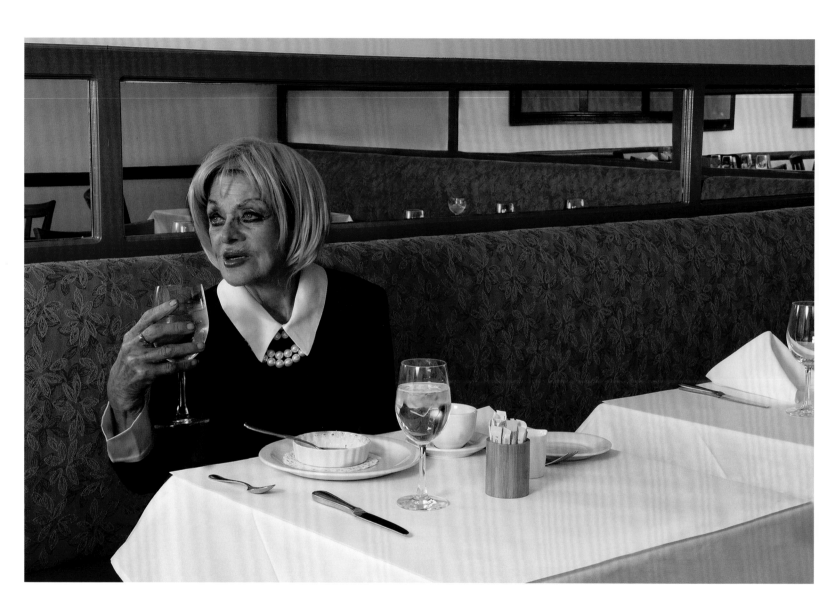

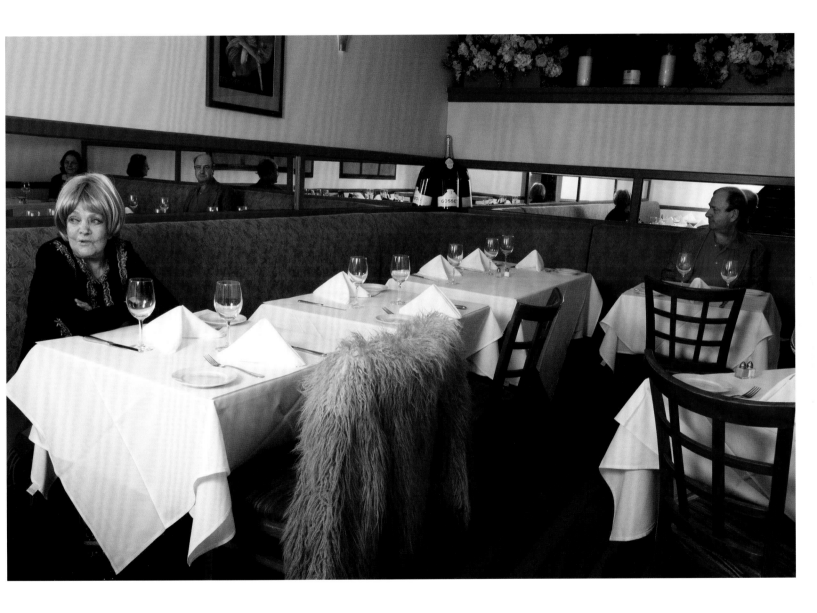

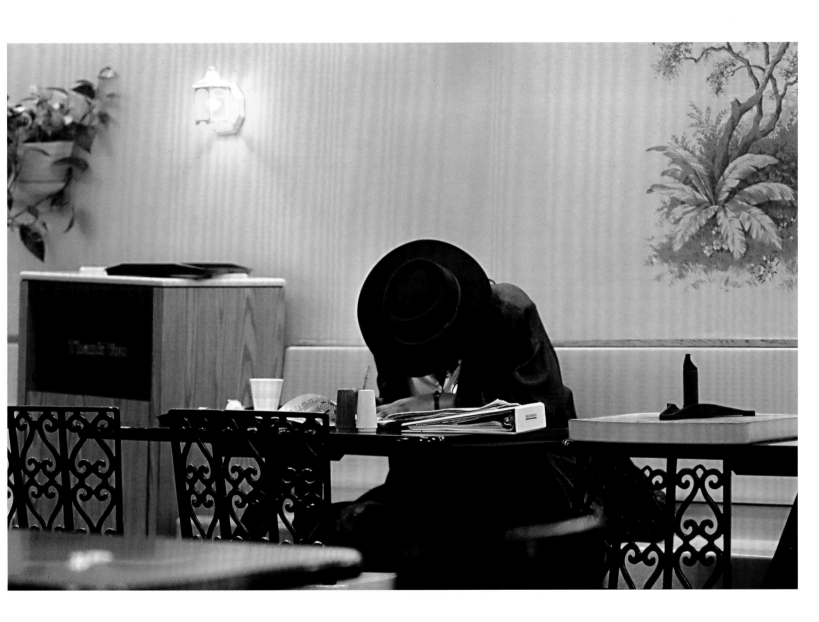

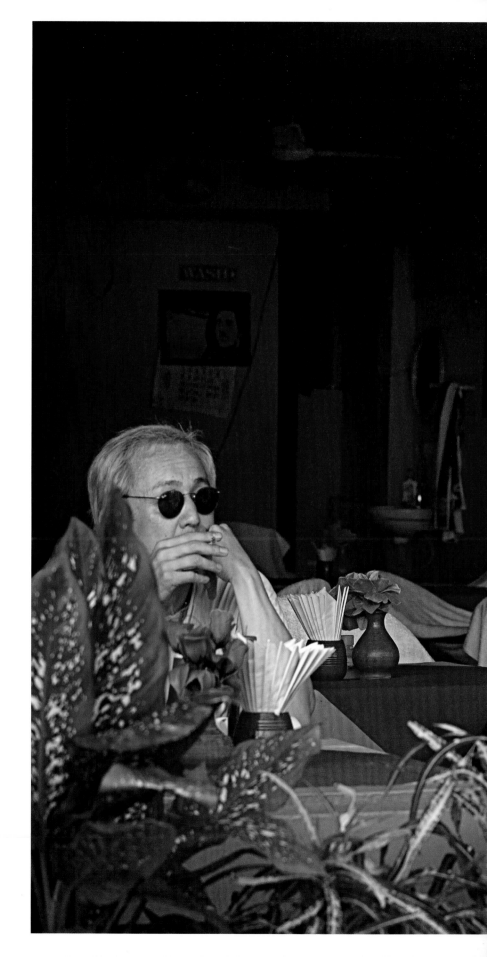

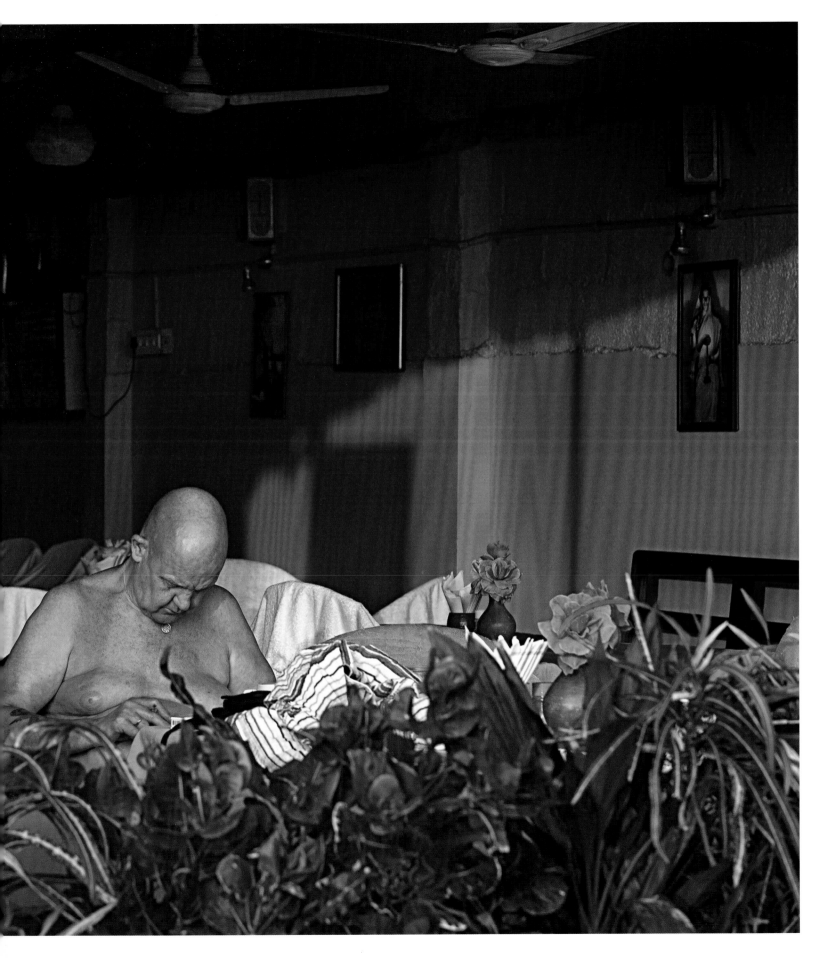

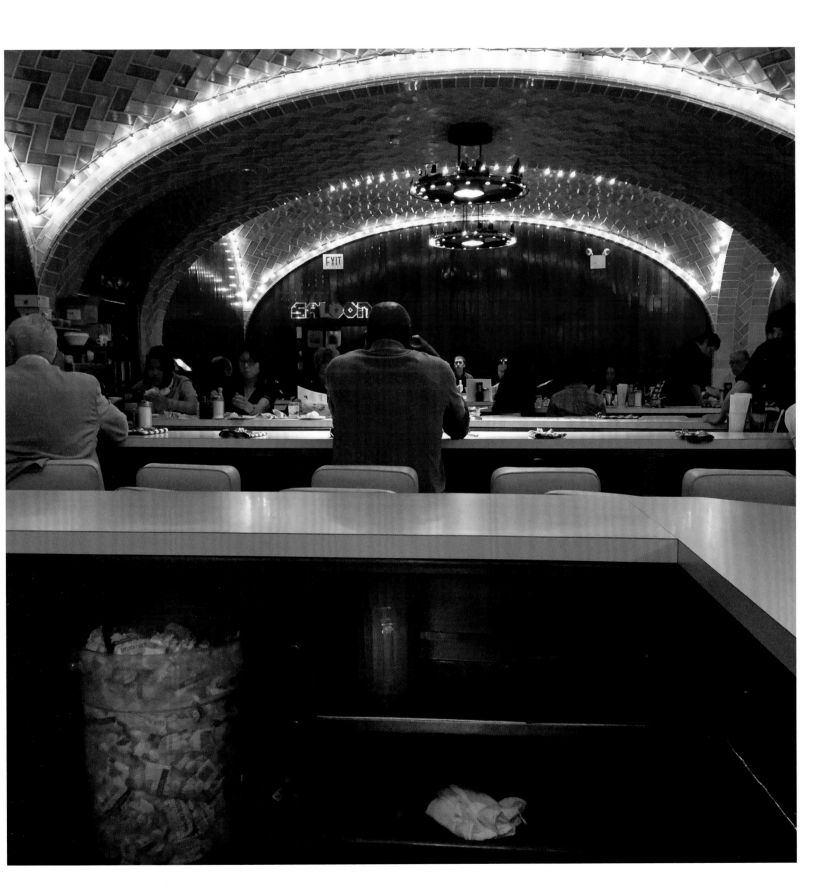

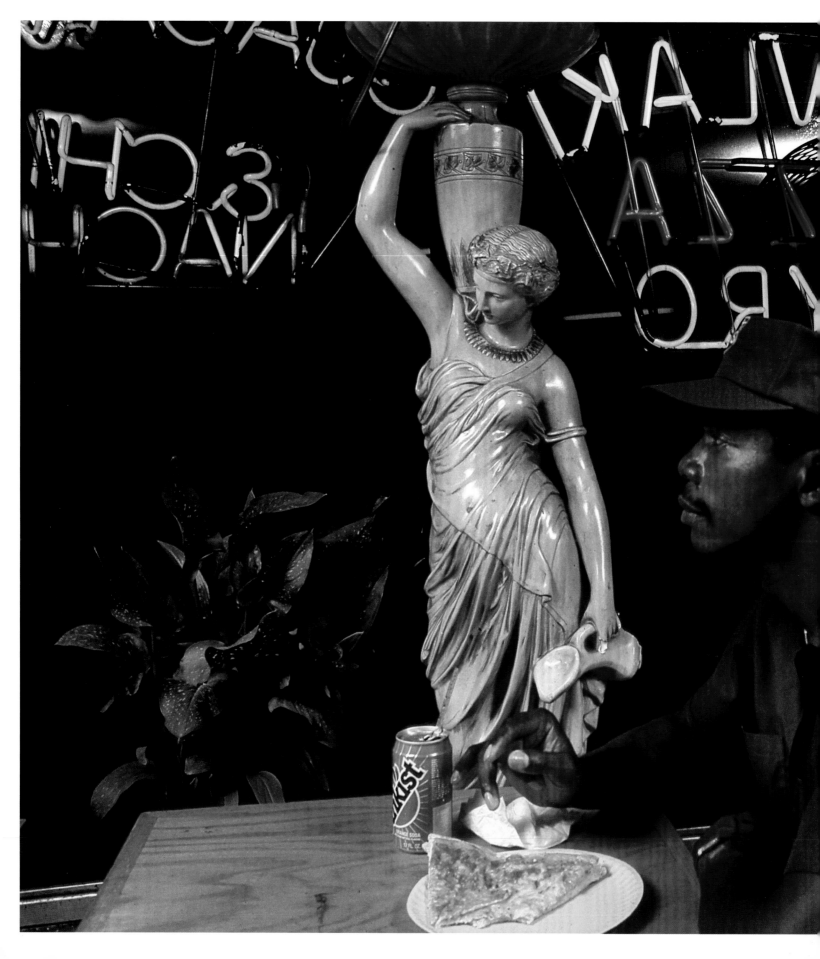

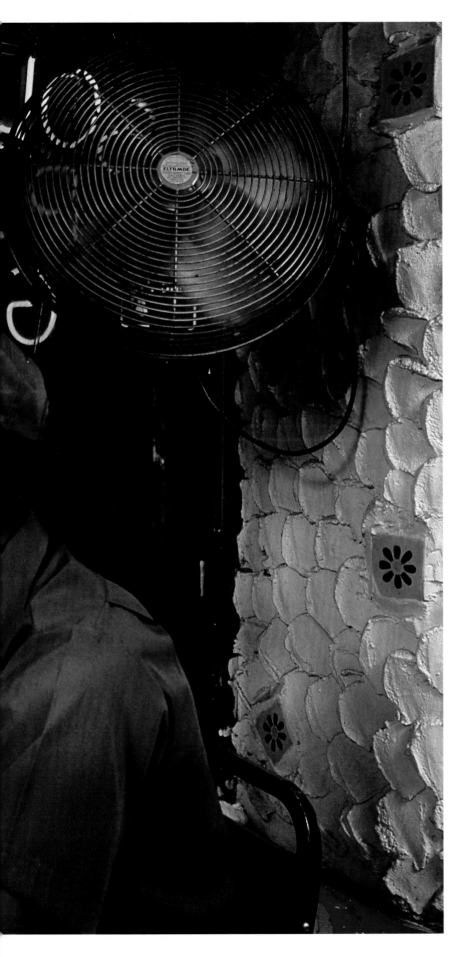

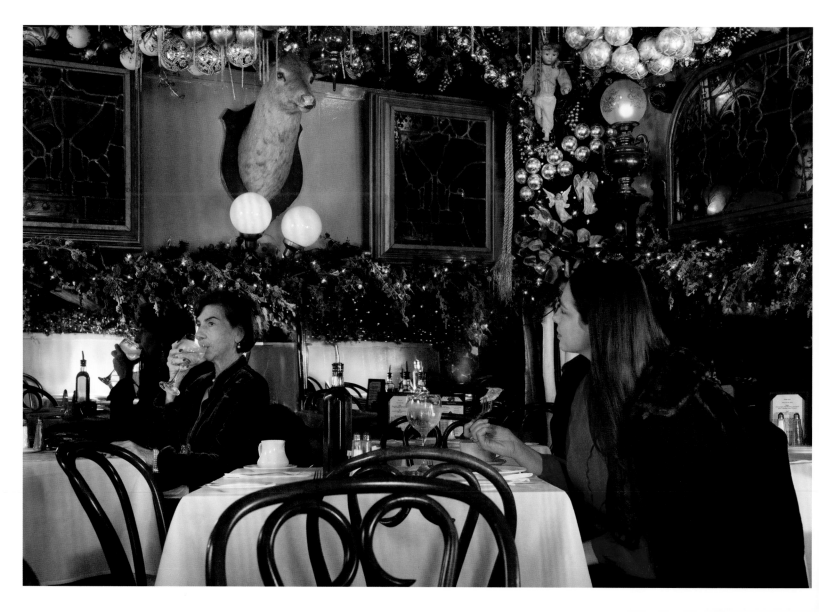

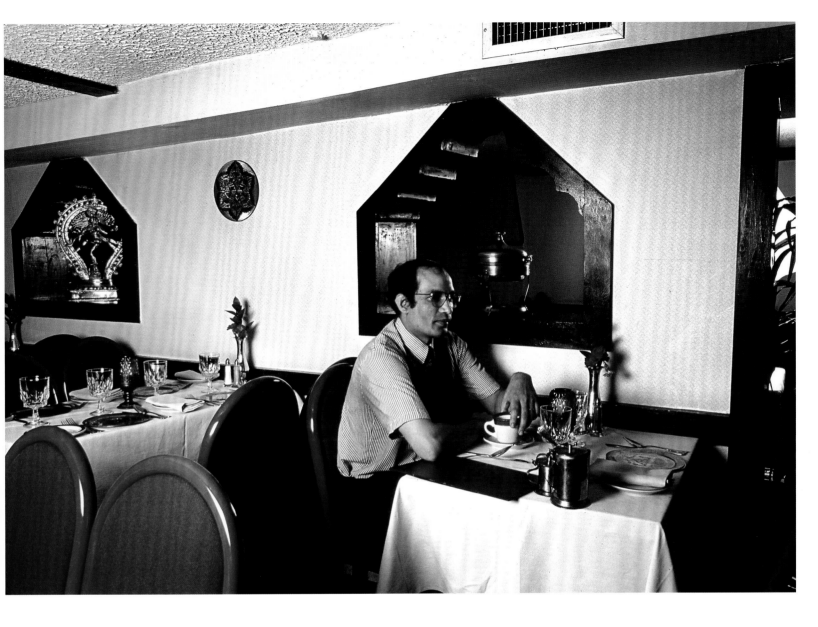

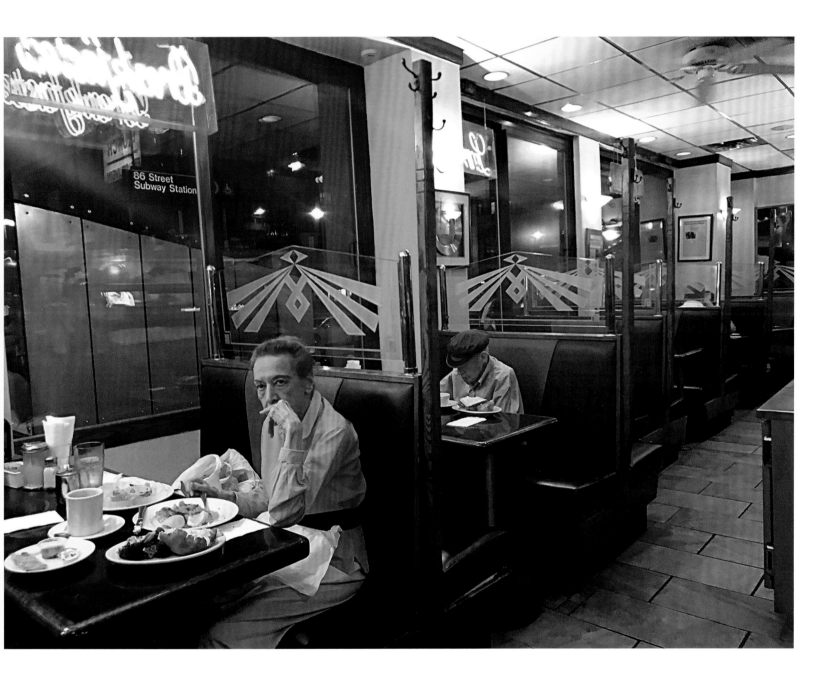

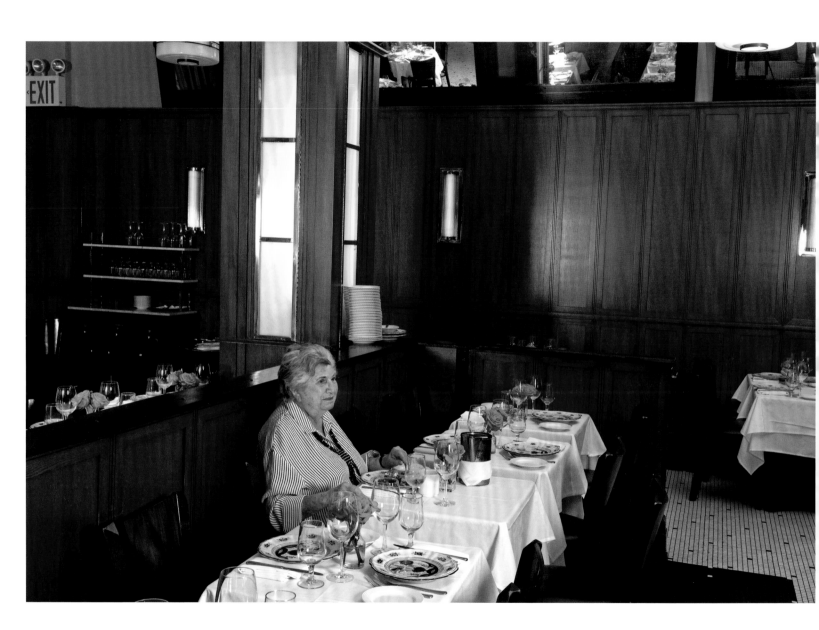

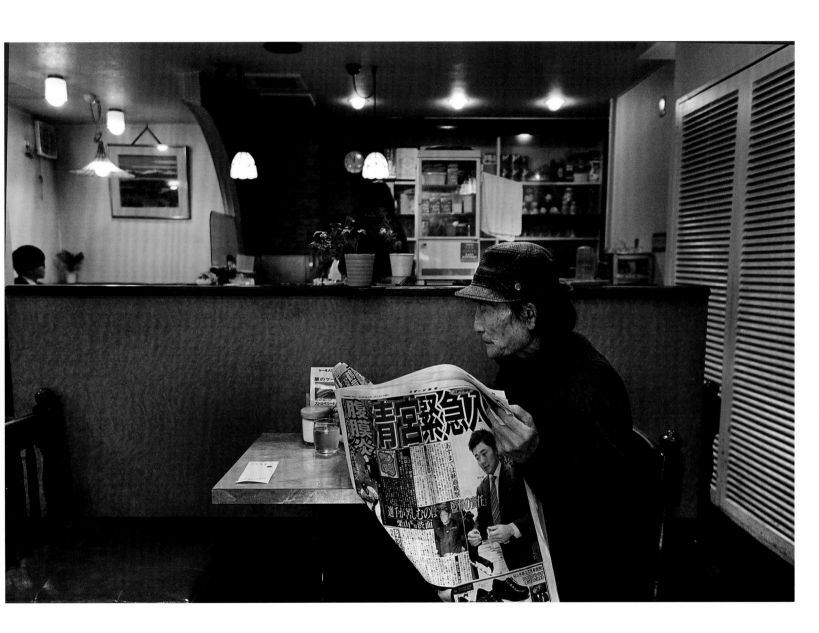

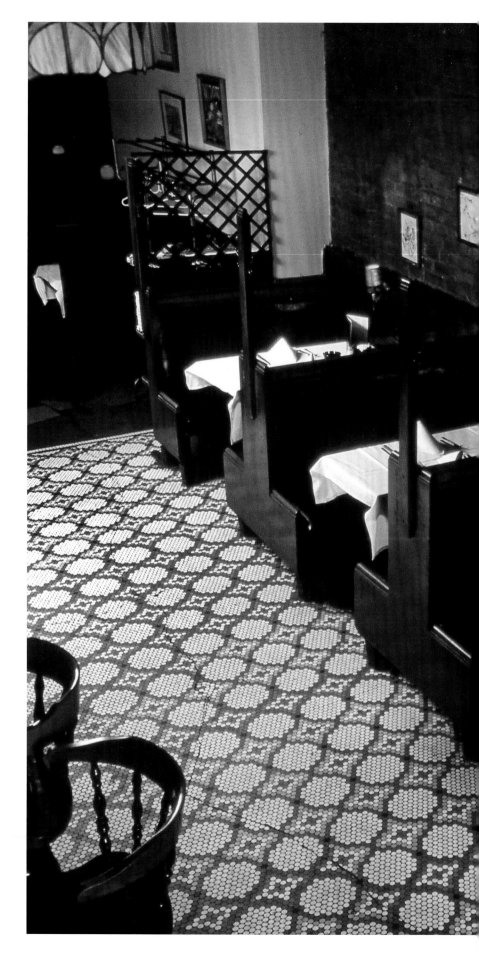

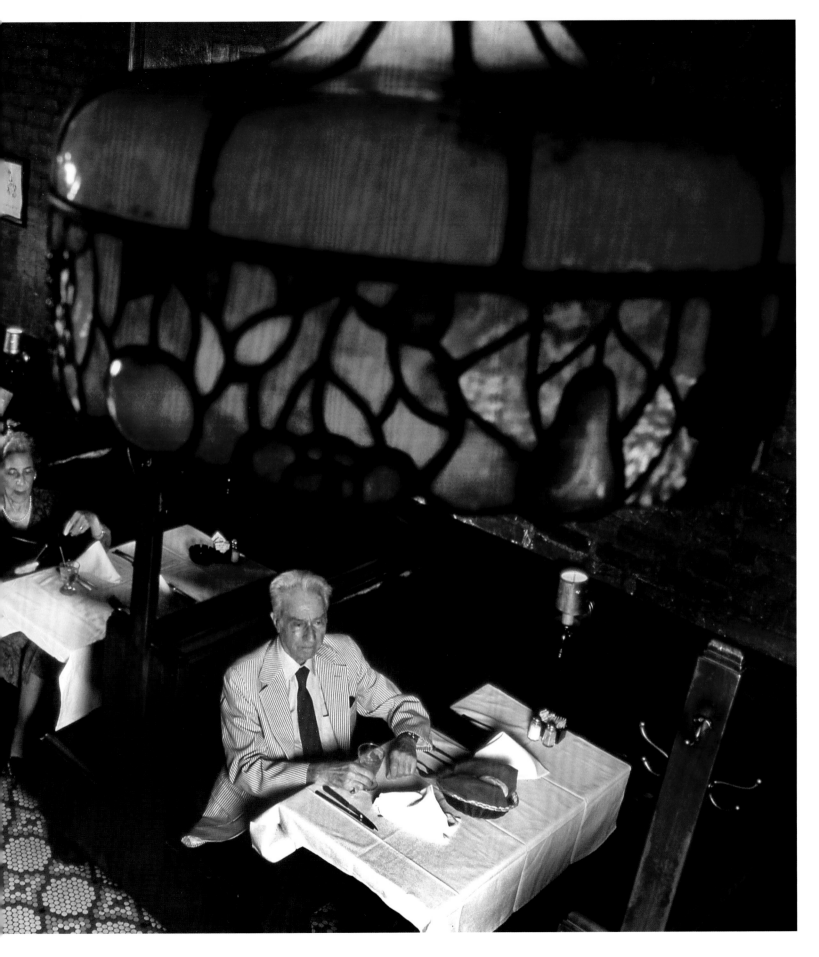

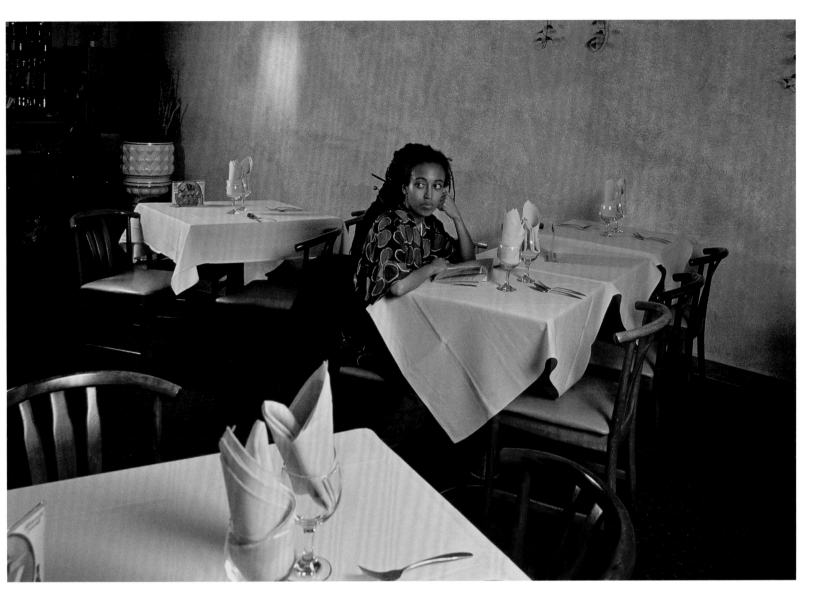

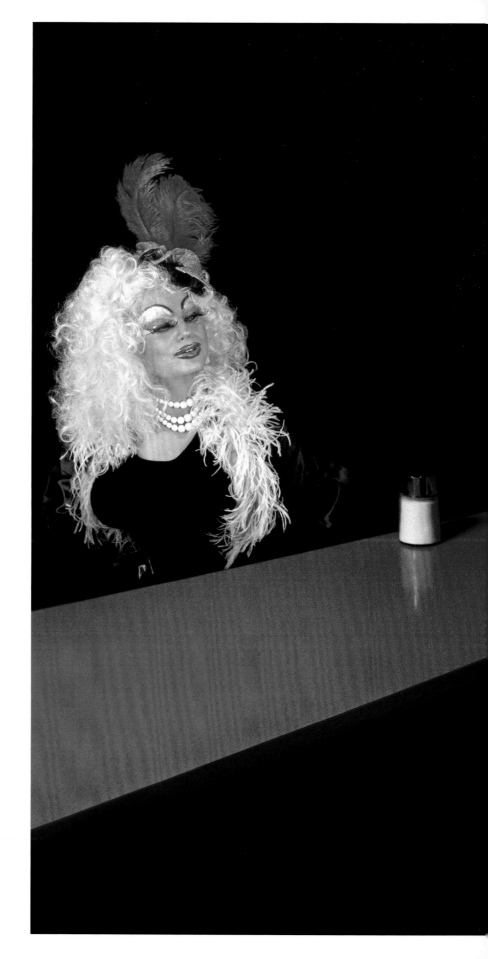

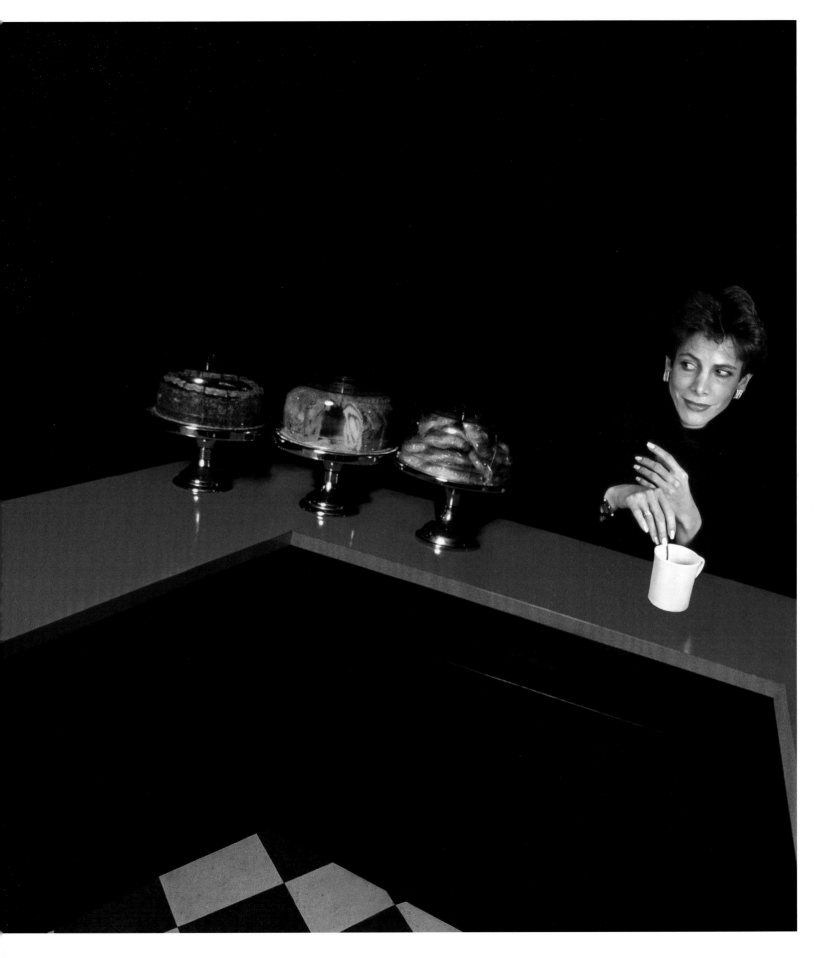

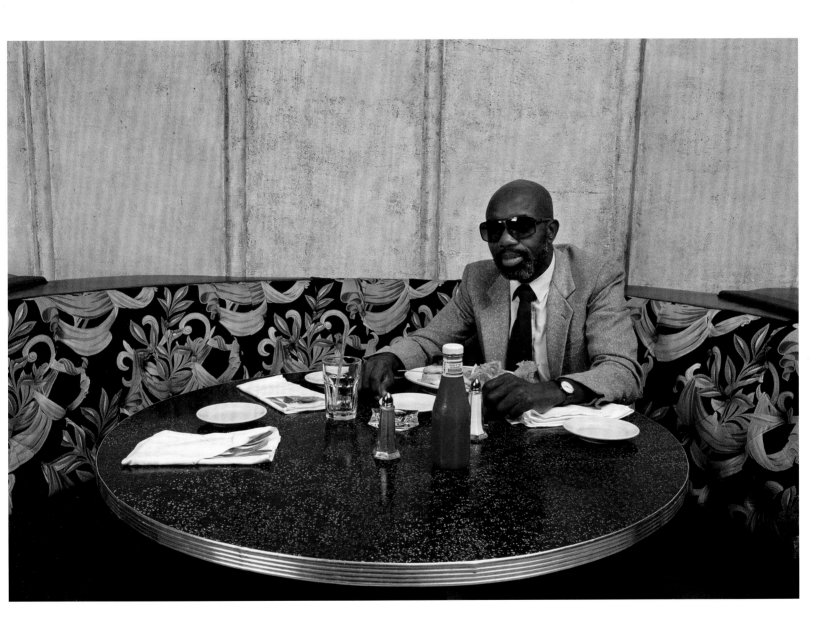

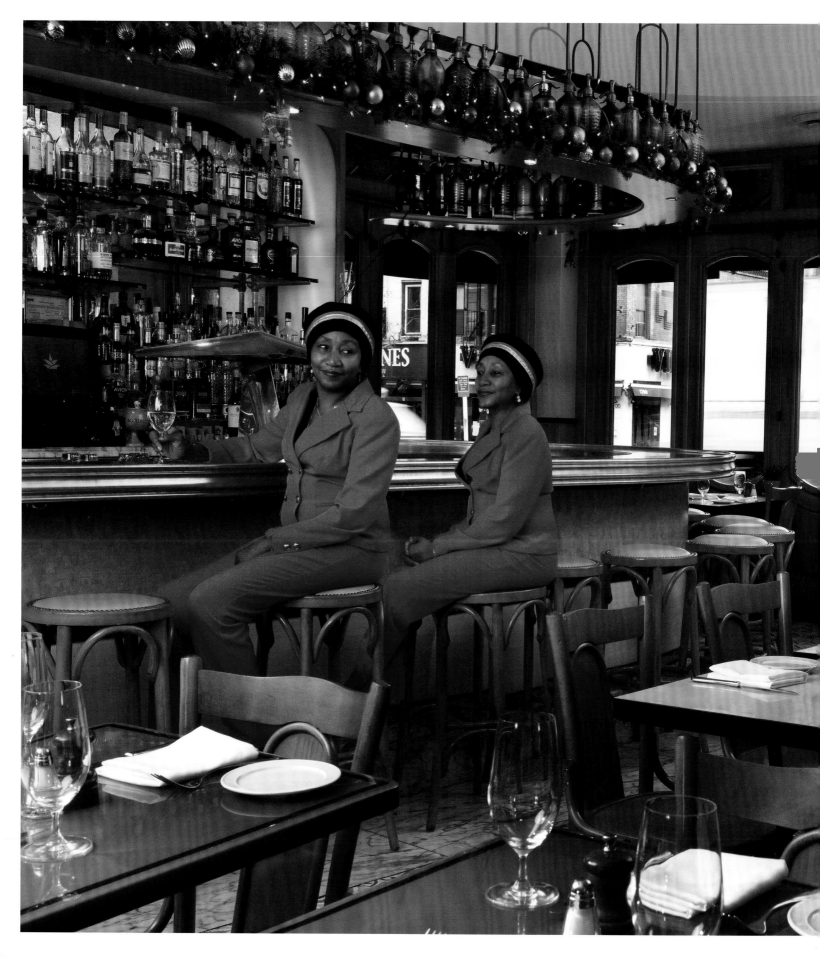

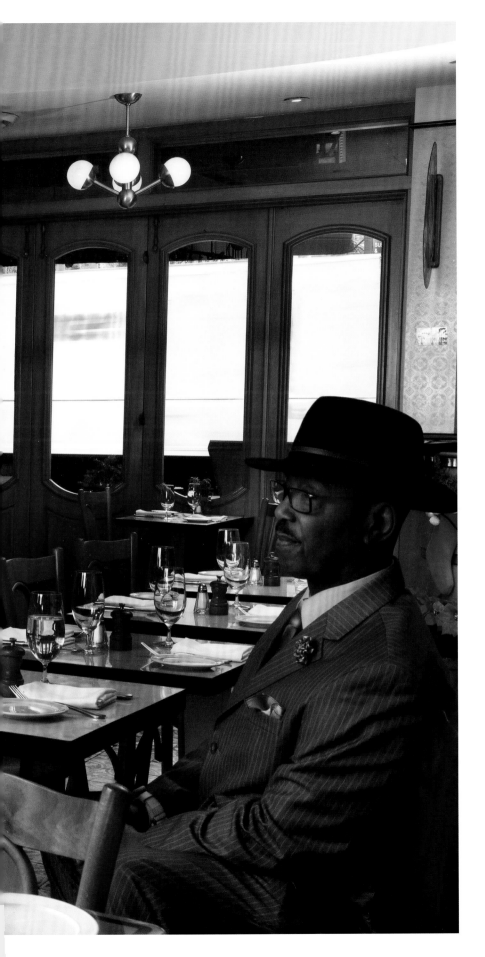

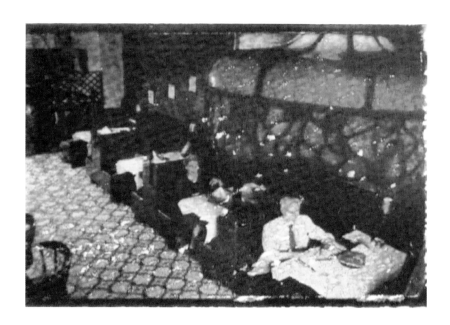

PART II:
Universal and Timely

Nancy A. Scherl

Worldwide, we are two years into the COVID-19 pandemic and *Dining Alone: In the Company of Solitude*, my metaphor for experiencing solitude in public, has taken on new significance. The imagery in this series, particularly in Part I, which I started in the 1980s, is symbolic of a condition that is timeless and universal among a subset of people—those who enjoy dining in restaurants, and more specifically, those who dine alone in restaurants; but the pandemic makes the condition of aloneness and isolation poignantly real for everyone.

Though I did not intend to expand the scope of this project, once I realized the impact that the COVID-19 virus had on so many of us, especially the elderly, by casting us into severe isolation from one another, I realized the importance of capturing what dining alone means during the pandemic. Perhaps the images in Part II will convey to posterity something of what we have lived through in the sphere of public dining with the presence of a lethal and highly contagious virus.

During the one-year span from the spring of 2020 to the spring of 2021 as the virus raged, restaurants underwent a metamorphosis. Many were forced to close due to a lack of business and unaffordable overhead, while others were open only for takeout. In February and March of 2020 some restaurants started to offer outdoor dining under legally specified conditions. Across the globe the restaurant industry was trying to find creative ways to reopen by exploring alternative environments for customers to feel safe in. Outdoor dining became very popular, since it allowed for better air ventilation than interior spaces could provide. Restaurateurs were supported by their respective governances to set up tented spaces that extended from the sidewalk areas of their establishments into parts of the adjacent roadways. Over time, the tented outdoor spaces were elaborately expanded to become more permanent dining zones. These ad hoc chambers for eating in a more isolated way, constructed sometimes out of wood and sometimes plastic, included windows and decor from simple to intricate and chic, often incorporating seasonal flowers in flower boxes, Christmas garlands and wreaths, lights, artwork, painted murals, and other creative touches. Many of these semi-outdoor dining spaces were transformed to resemble different times and places, giving diners a place to escape the daily stresses, just as restaurants have always attempted to do, but this time from the burden of the pandemic. As the weather became colder, tented dining spaces were equipped with heaters. The individualized structures were built more solidly, using wood, hard plastic for the windows, and plastic rooftops with ridges to allow rainwater to run off. Heavy-duty car bumper protectors were sometimes used on the outside walls of the spaces that were now extending into a portion of the streets.

Restaurateurs exercised diligent flexibility to maintain their businesses and communities showed their spirit, as much as their need to connect, by coming out to dine. Despite the marginally effective designs for dining in isolation, given that the six-foot distance rule was not rigorously applied and airborne virus particles were unlikely to be contained by plastic

sheeting, restaurants reopened, and patrons came. Whether in denial or to seek normalcy, people defied the virus and began eating out more often. Those who would have been dining alone pre-pandemic were now on par with other diners, intermingling inconspicuously.

Individual diners in the peopled restaurant interiors in Part I of this book might have experienced themselves transported in a themed, dignified, or ultra-decorated restaurant, in some way their experience of being alone favorably enhanced. In the time of COVID-19 dining everyone became more attuned to their immediate environment. Anxieties about one's well-being clashed with the desire to escape to normalcy or to be someplace else that themed restaurant decor, by design, supported. Dining with the threat of COVID-19 ever near could not be stress-free despite efforts toward normalcy.

The frequently changing design schemes for outside dining were also visually disorienting. Familiar landscapes transformed almost daily, as rapidly updated outdoor restaurant spaces continued to become more and more commonplace in cities, towns, and suburbs across the world. The rapid and evolving transformations of our city spaces, and their strange impermanence, seemed surreal. The ever-changing landscapes that I saw around me in New York matched evolving dining environments across the world. The medley of images that I saw in my own locale and that in my mind I projected visually to the world at large collapsed in my experience to a sense of immediate connection across countries, cultures,

and neighborhoods. I recognized that every human being was experiencing the same need to adapt. Even more universally, the adaptations required of us in how we dined were mirrored in the adaptations we were required to make psychologically and physically in all areas of our lives. None of us were alone in the need to adapt. We strained to adapt—one and all—together. Our uncertainties about how to adapt grounded us in the need to find a way forward together, however disorienting visually, physically, and emotionally that way forward might be. In the need to be normal and safe in the presence of an invisible and lethal viral danger, the sameness of being alone in our dining reality, no matter who the diner might be or where, was evident. Dining alone in the company of solitude—the imposition of that circumstance became vivid for everyone.

What I witnessed in individuals dining alone pre-pandemic was now all around me but exaggerated. Memories of dining alone pre-pandemic became ever more faint as COVID-19 isolation approached its first full year. I wondered how much of the change in dining environments would become our new normal. Pandemic isolation was profound on many fronts— we were all physically isolated in varying degrees and, tragically, very often psychologically isolated. The fears and hardships that have beset us and continue because of this pandemic are profound. The contagion of COVID-19, with its constant, dangerous mutations of the virus as the virus itself continues to adapt, is astounding. Once the vaccines started to become available, challenges in distribution and the necessity for continued masking and social distancing themselves

pressed against the tide of people desperate to return to life as they knew it. The isolation for elders, for families unable to visit with their elders, or for patients with COVID-19 in hospitals, many of whom could not be visited by their loved ones, was simply overwhelming. We all had to bear the reality of keeping ourselves safe from one another, a particularly distressing form of aloneness.

Yet despite all the challenges and sorrows of isolation and being alone, from an existential point of view this pandemic has provided a definite and also universal life-changing perspective. While aloneness is built into human life—at least in the moments just before birth and as we die—the pandemic poignantly reminds us of our mortality and that the fragilities of life do not discriminate. We are perhaps paradoxically reminded that even in our aloneness, we are very much connected with each other exactly because of our very existence and vulnerabilities.

Dining Alone: In the Company of Solitude is a statement about our human condition. At this time, with all of the uncertainty about the virus that pervades our lives, I find it consoling that we may become humbled by this pandemic. We are not so different from one another; we are all experiencing similar concerns, uncertainties, and vulnerabilities. When people "dine alone in the company of solitude" today, they may feel a heightened sense of isolation and even fear, but in aloneness we share a common ground of vulnerability that this lethal virus has made clear.

Will our experiences of being alone during the pandemic change the experience of dining alone once we have survived the virus? By then, perhaps, we will all have transformed through an existential shift into a sense of togetherness that our current solitary experiences created. Newly awakened to the meaning of shared experience, our own mortality and the fragility of human existence, we may know in a very palpable sense that we are intimately connected with others.

Overall, the restaurant scene during the pandemic served as a symbol of how beyond the norm our lives during the time of COVID-19 became. My hope is that our experiences of dining alone during the pandemic, reflected in the images in Part II, will in time become memories that are no longer quite so real, more like Polaroid transfers, faint and indistinct, leaving an aging, fresco-like impression, something softer, less sharp. But perhaps these photographs will also serve as an encouraging reminder that we came to terms with our aloneness while we dined.

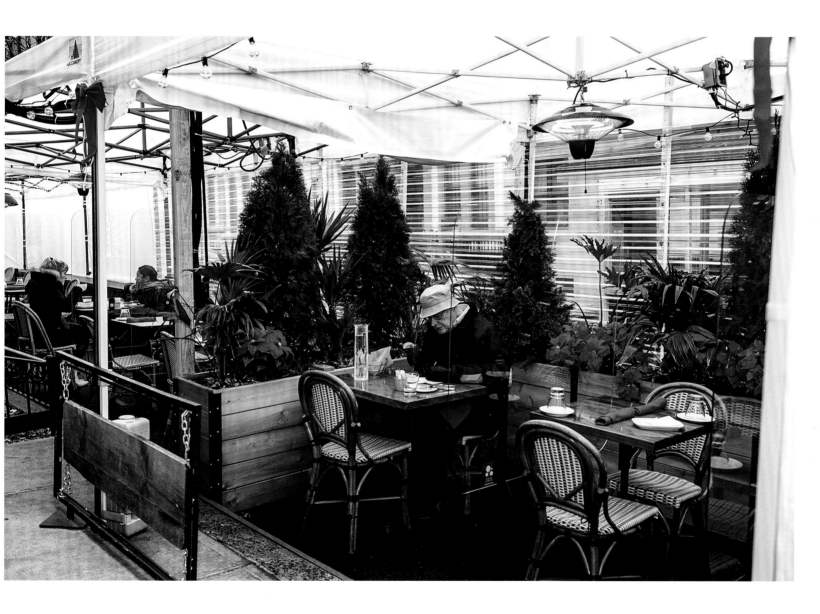

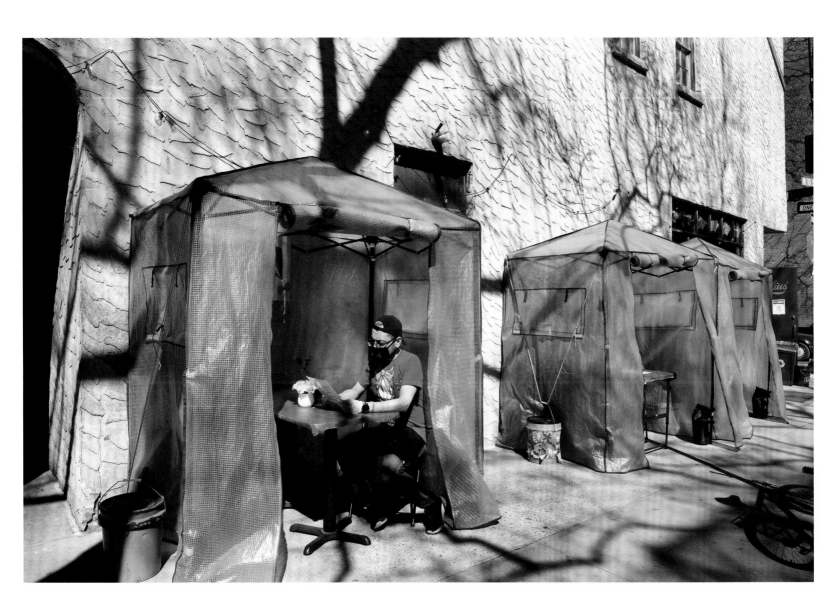

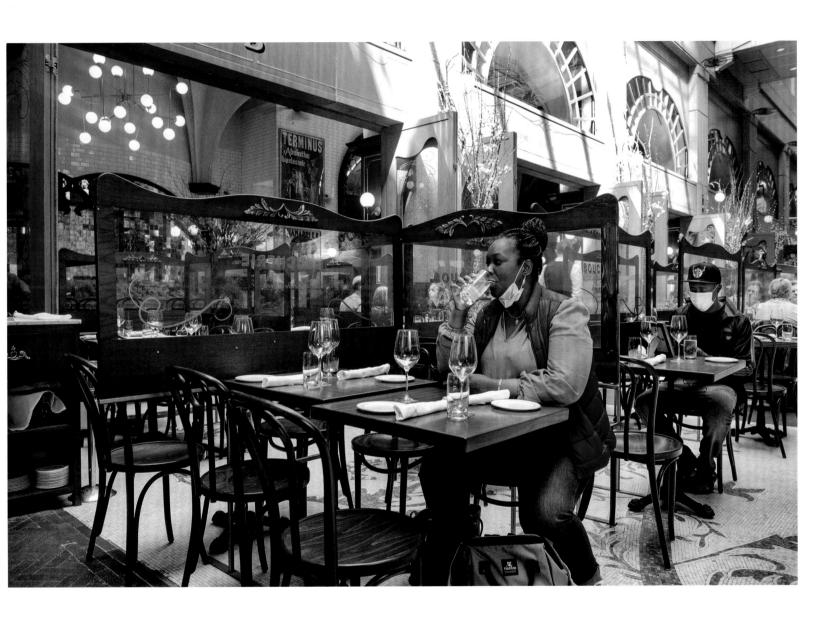

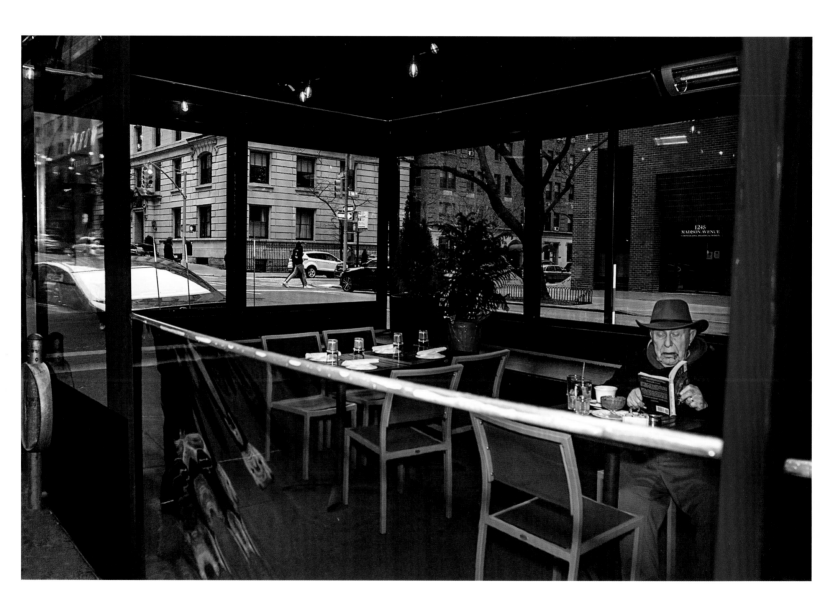

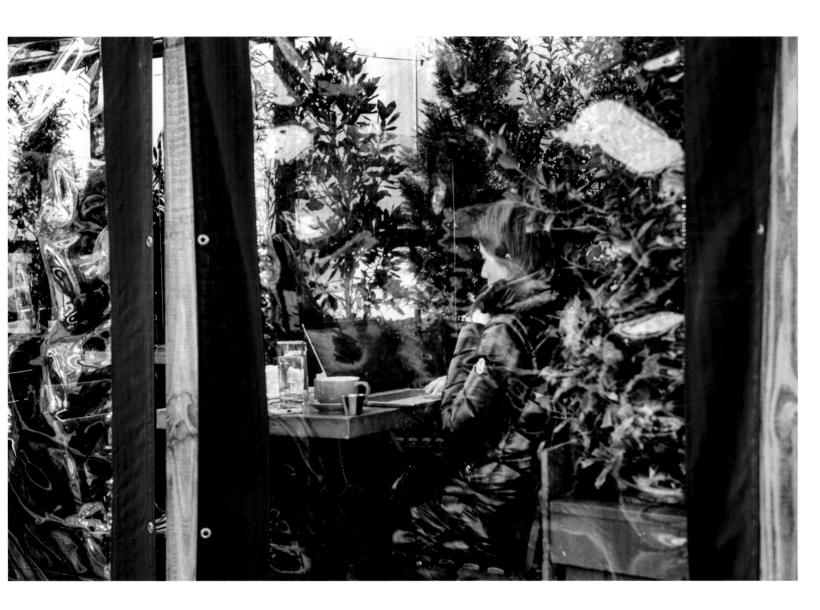

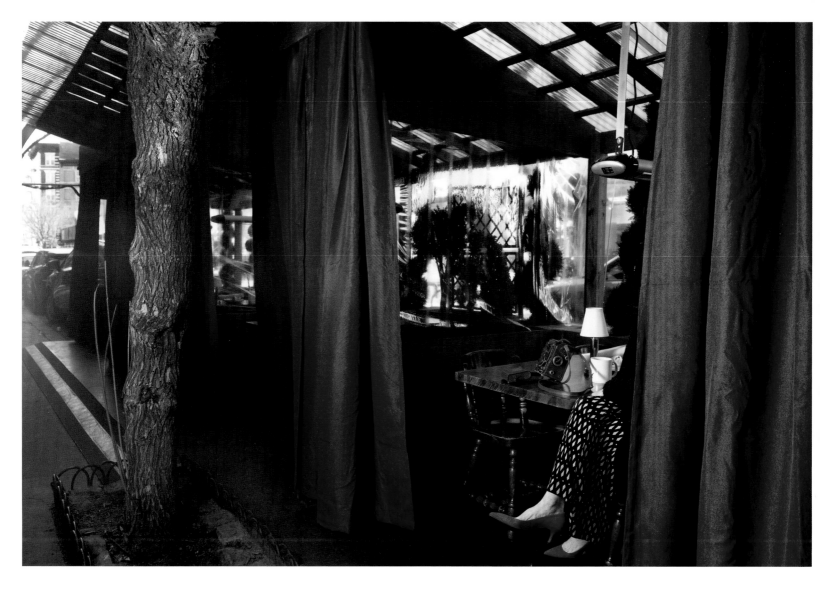

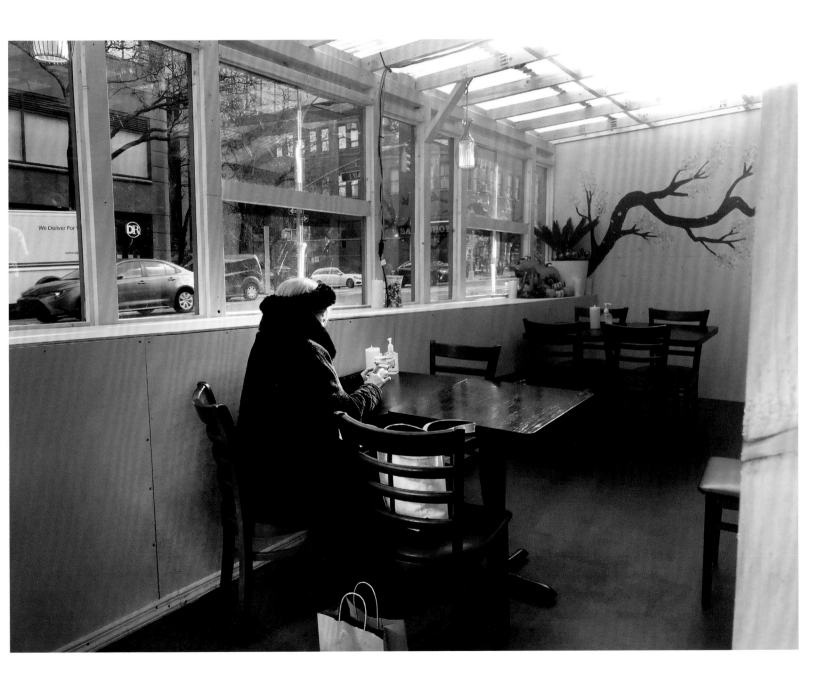

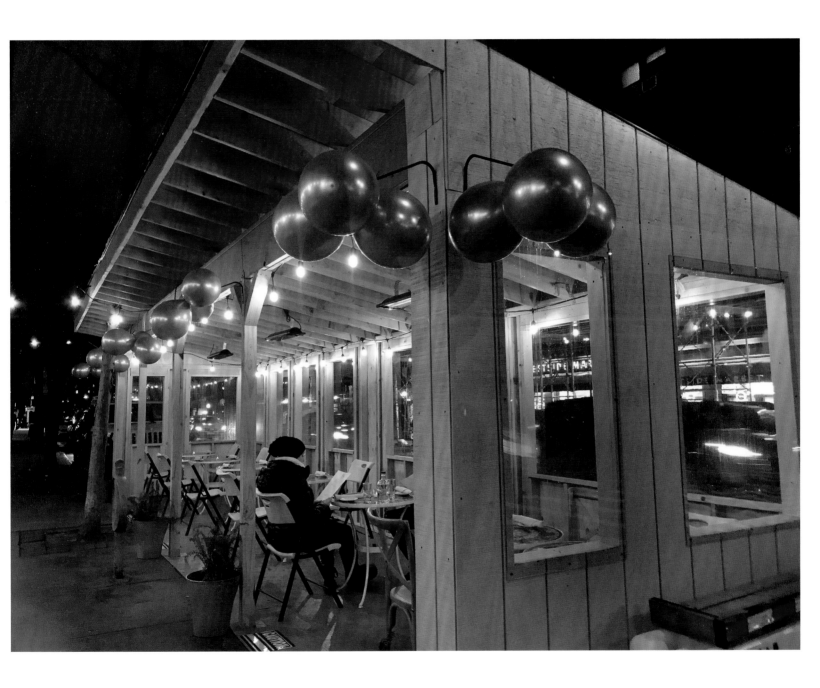

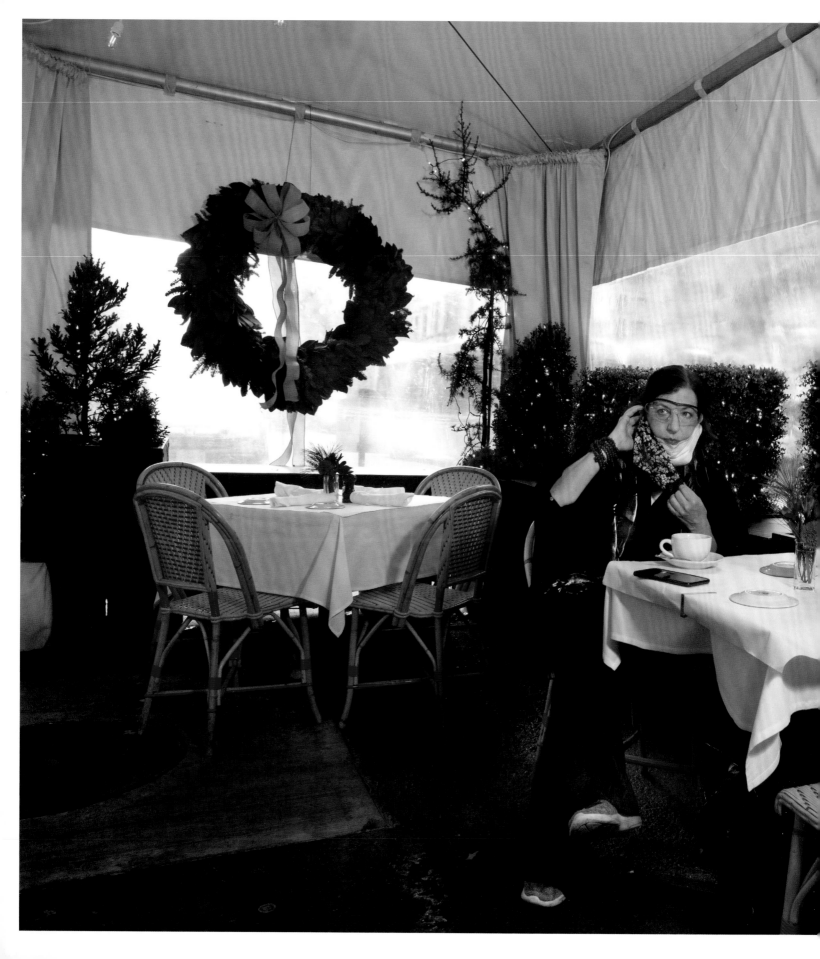

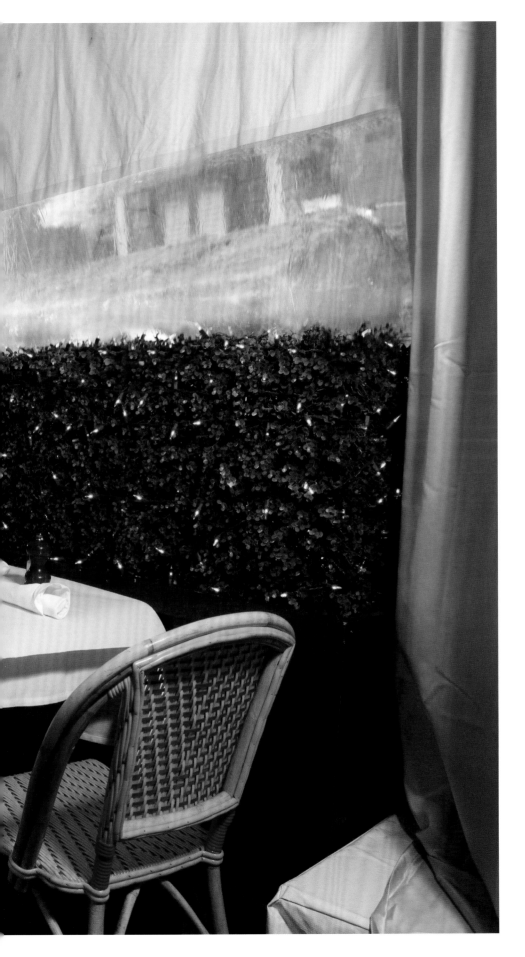

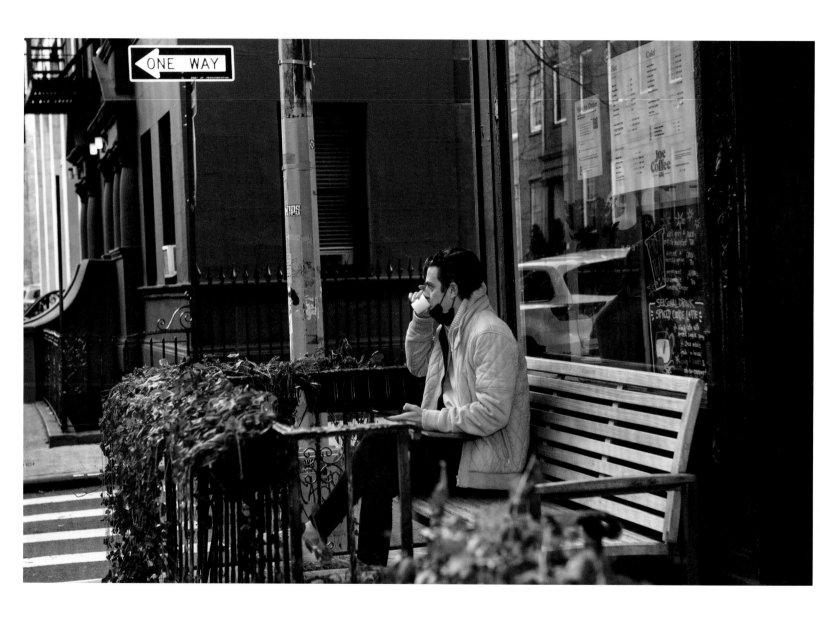

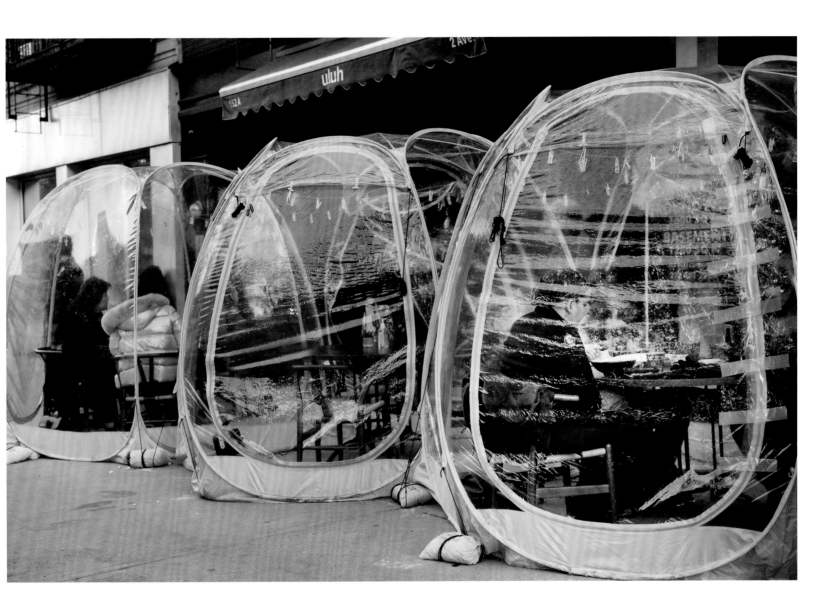

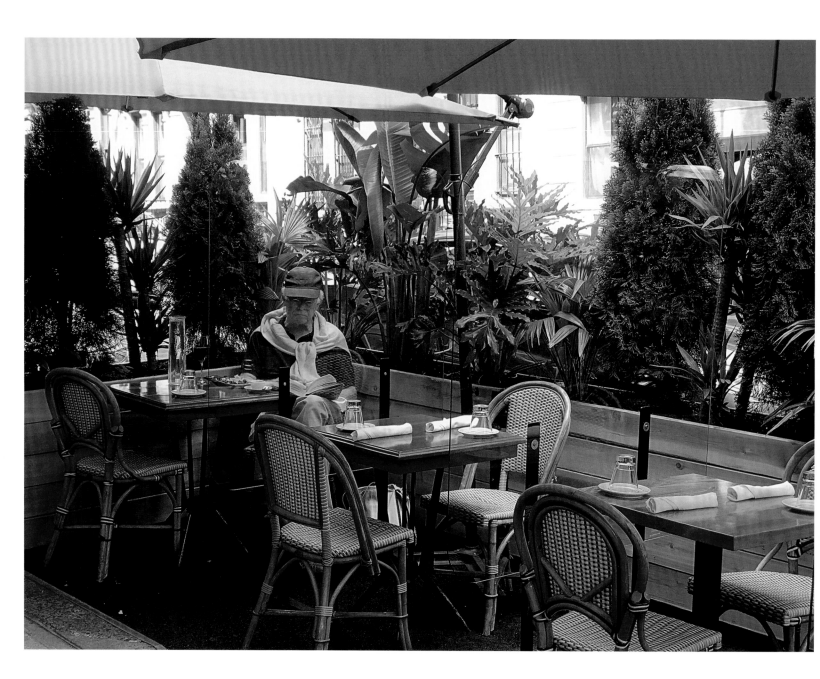

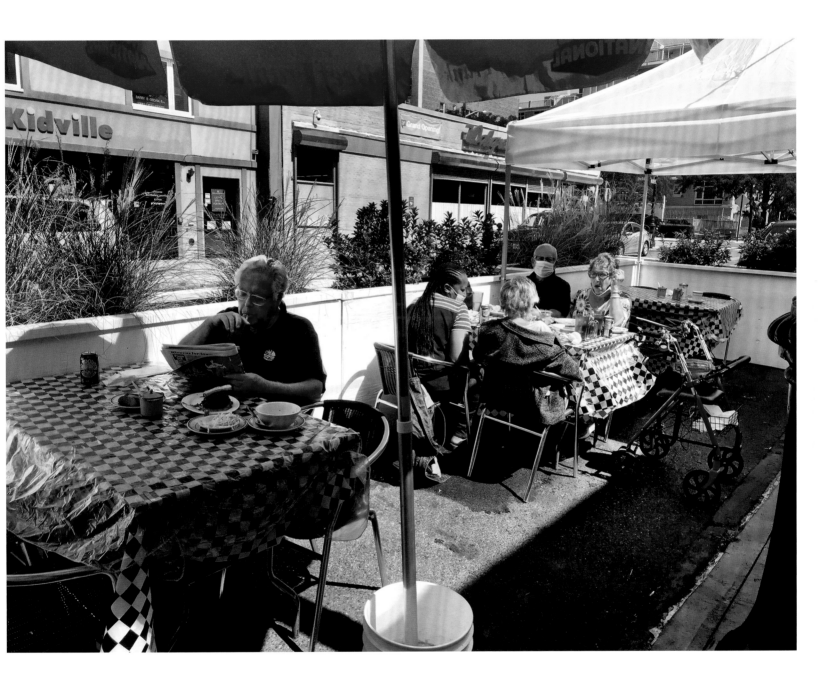

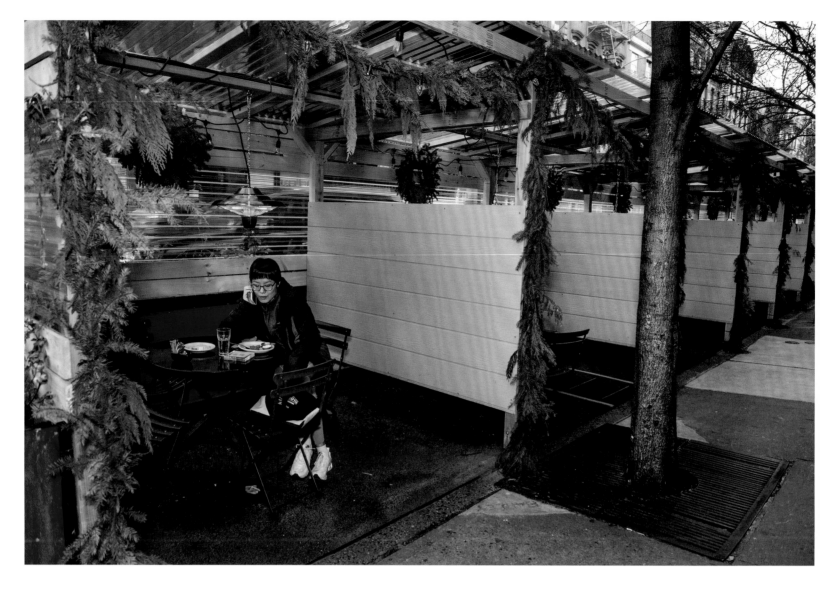

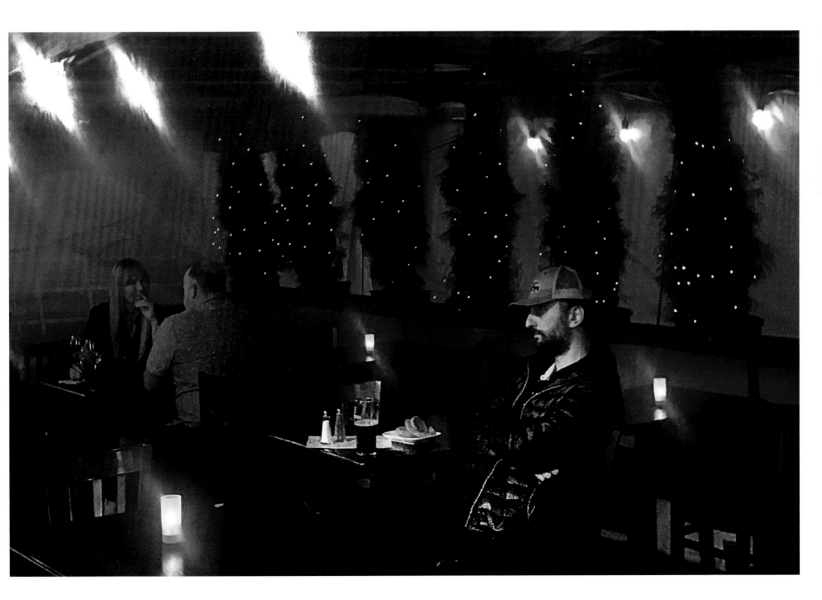

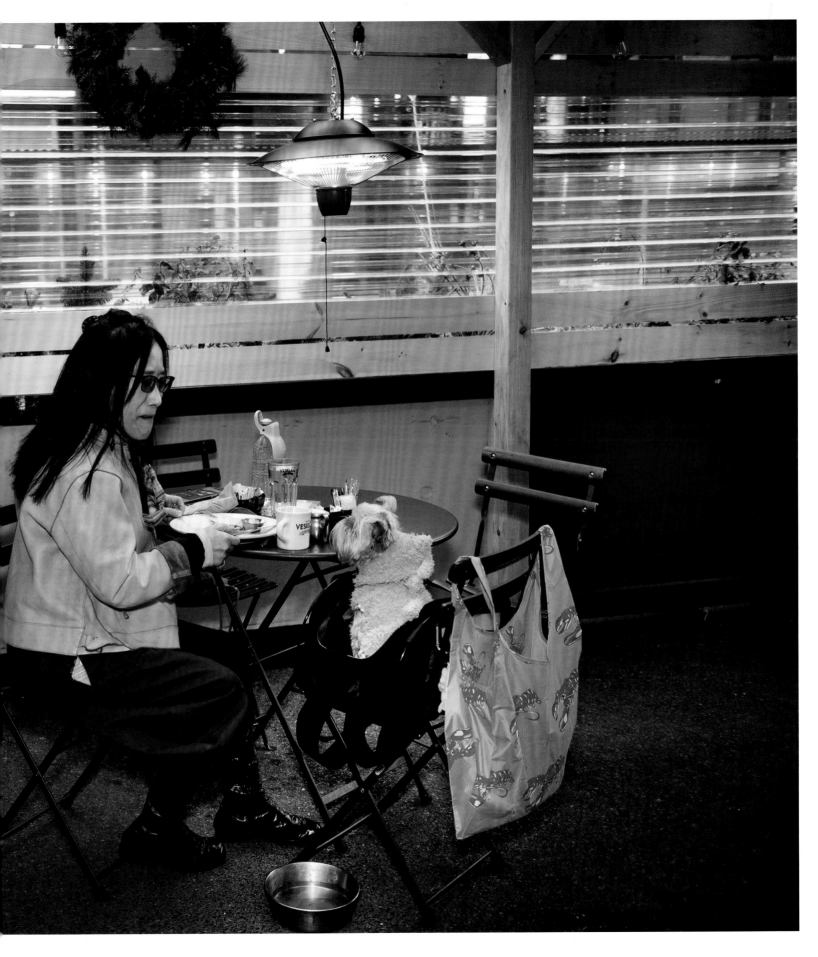

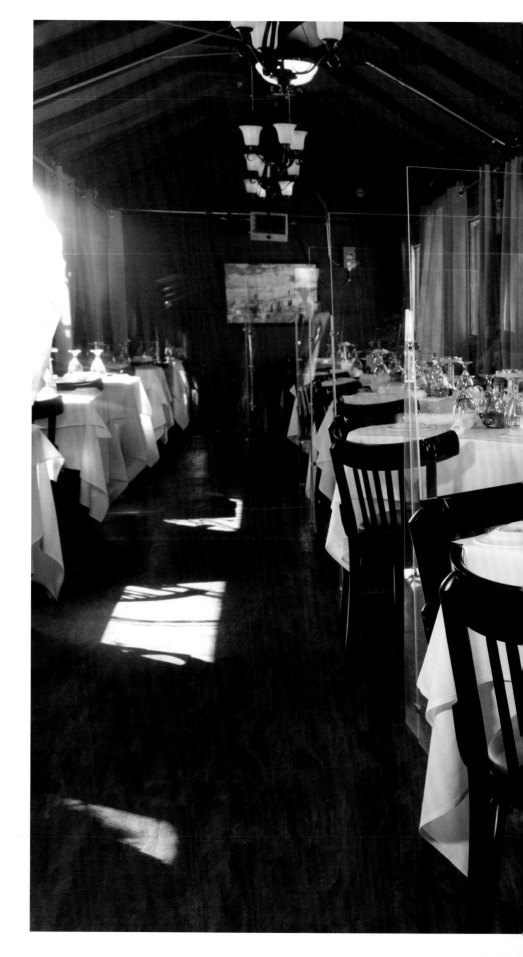

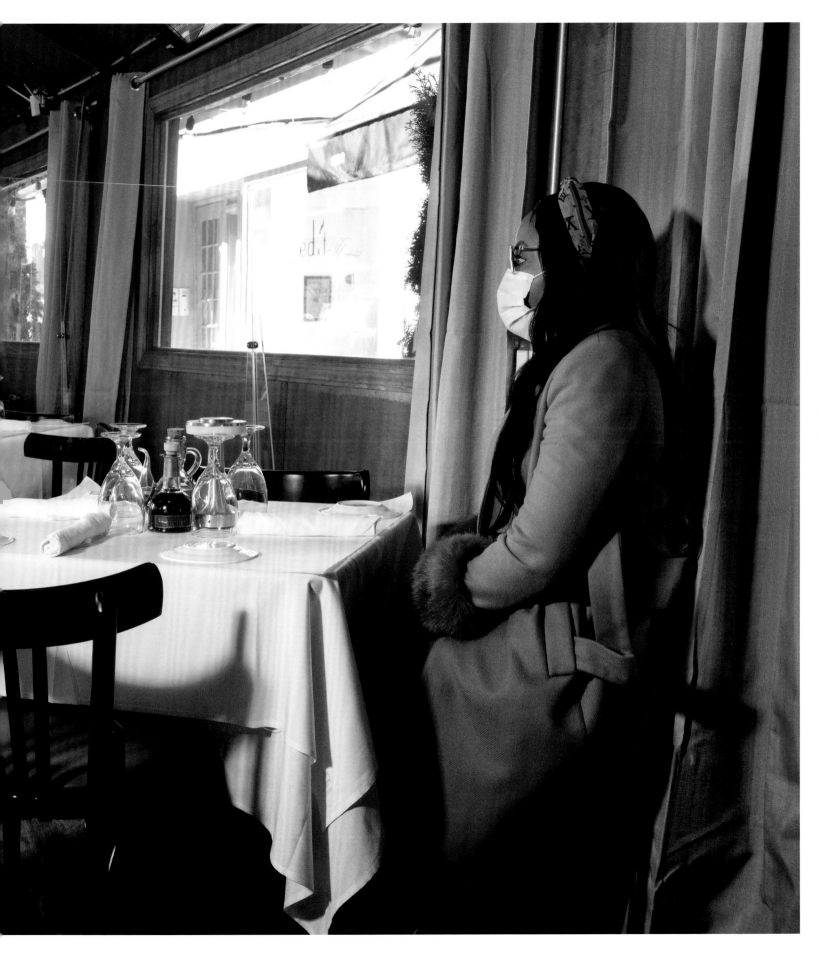

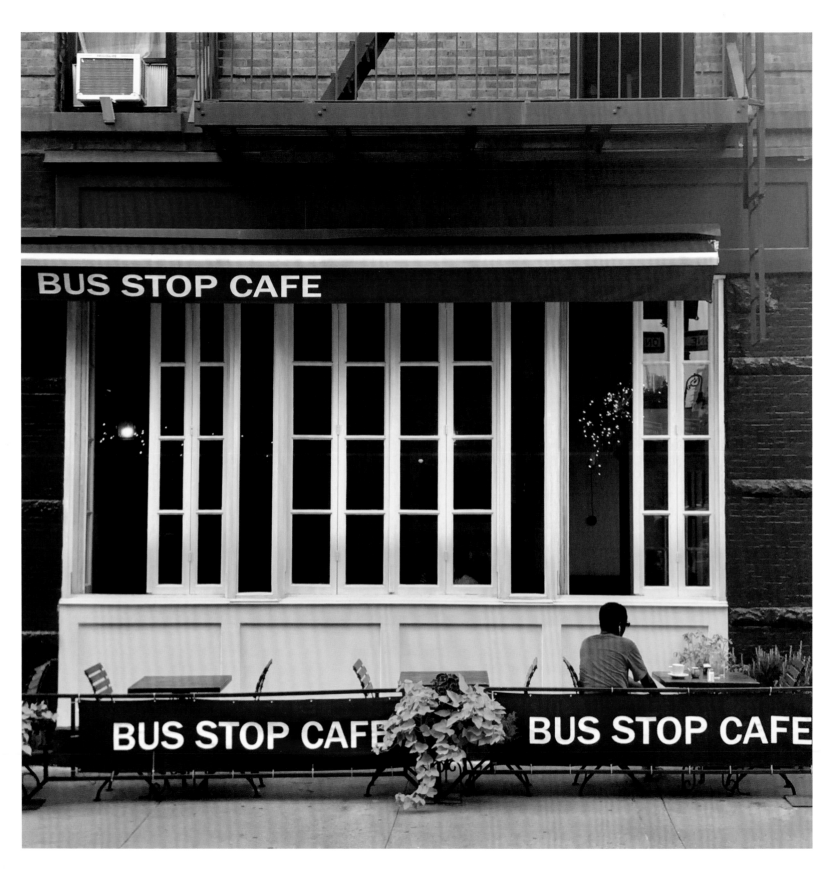

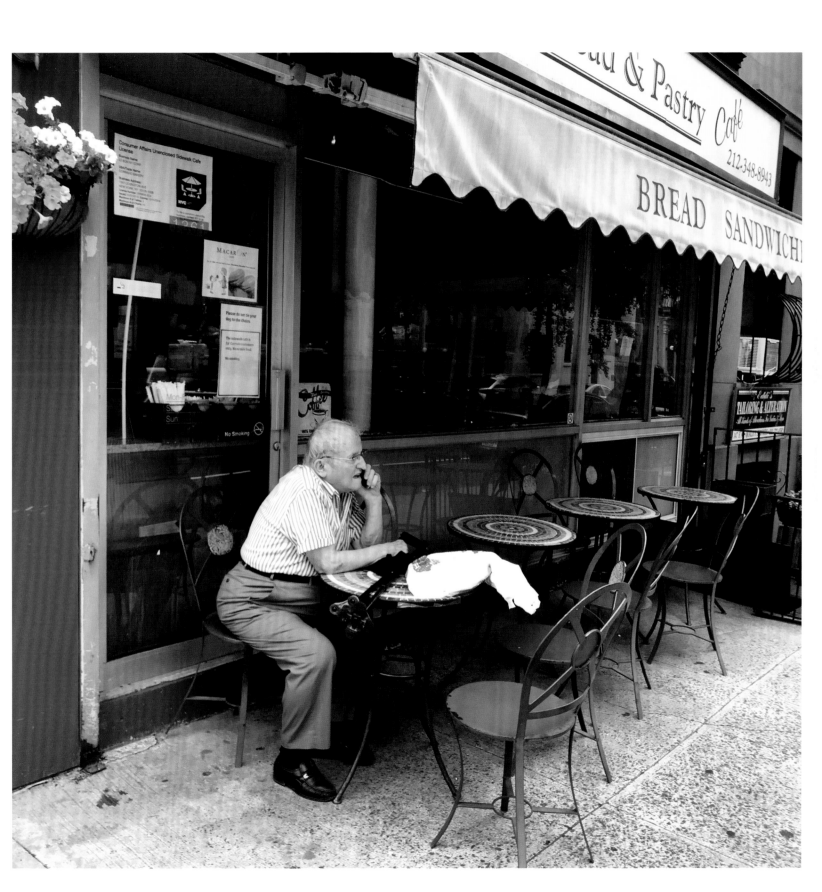

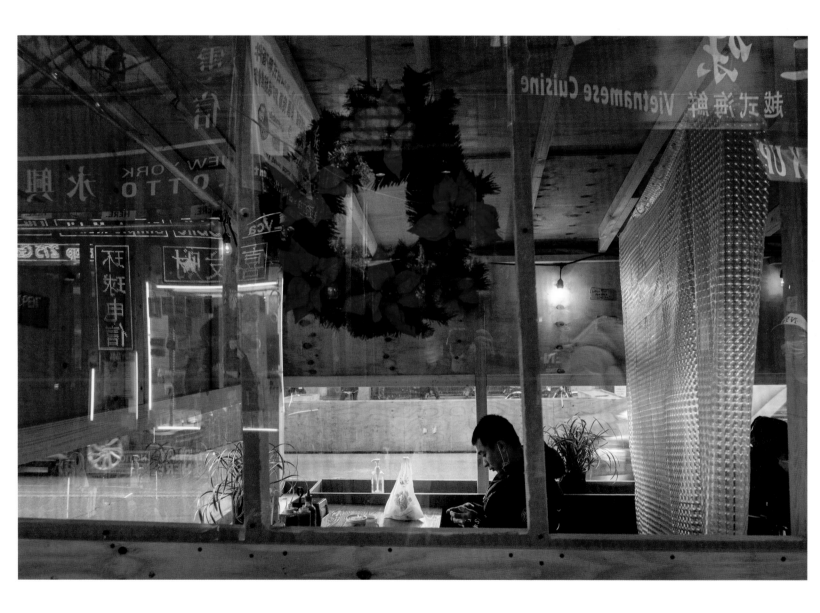

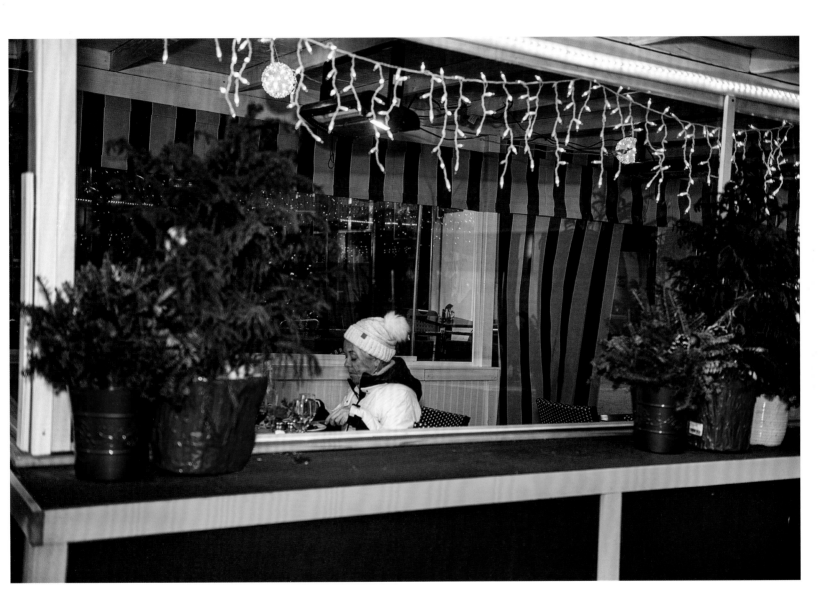

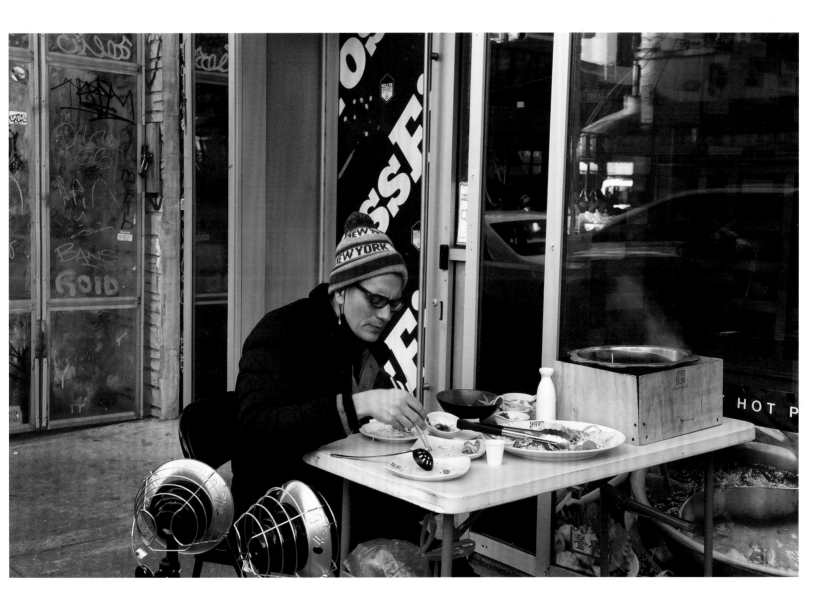

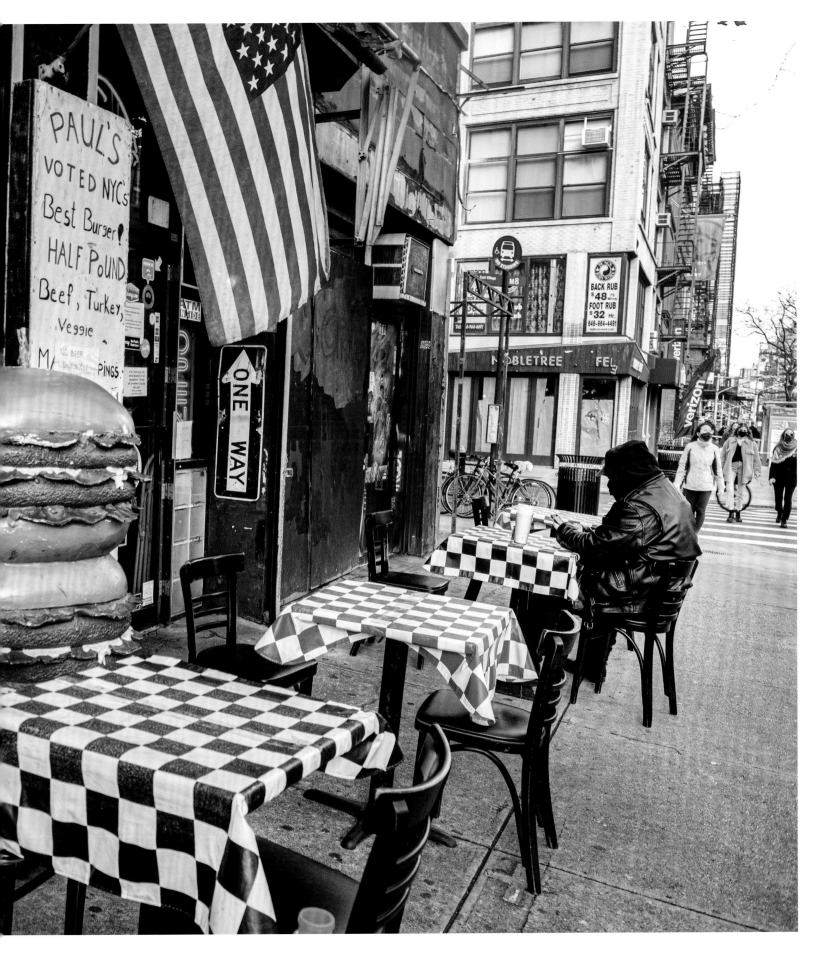

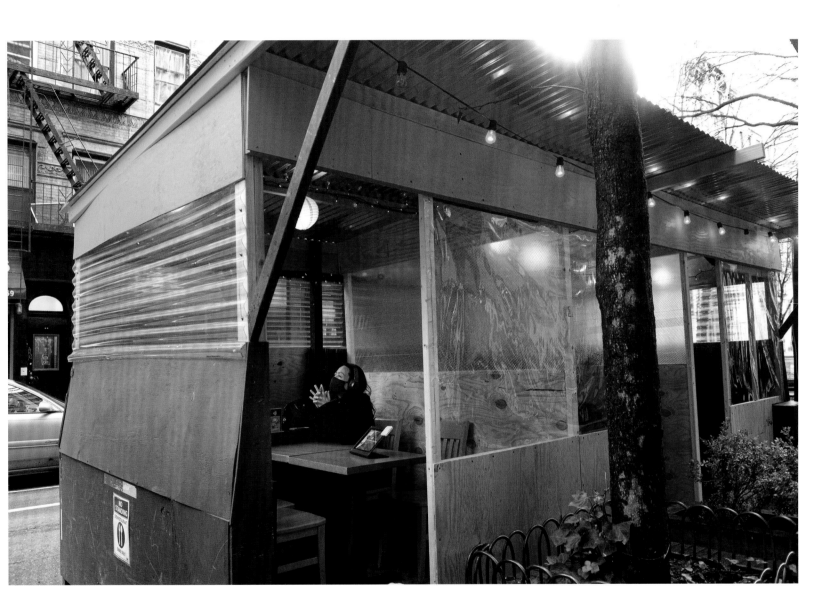

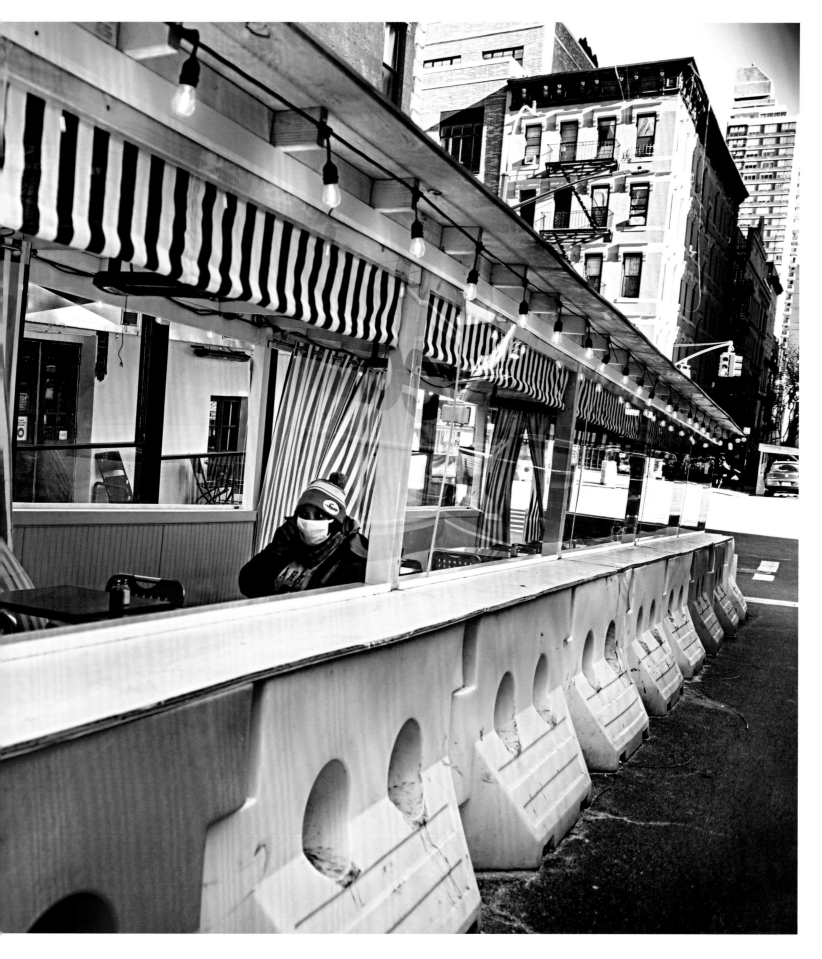

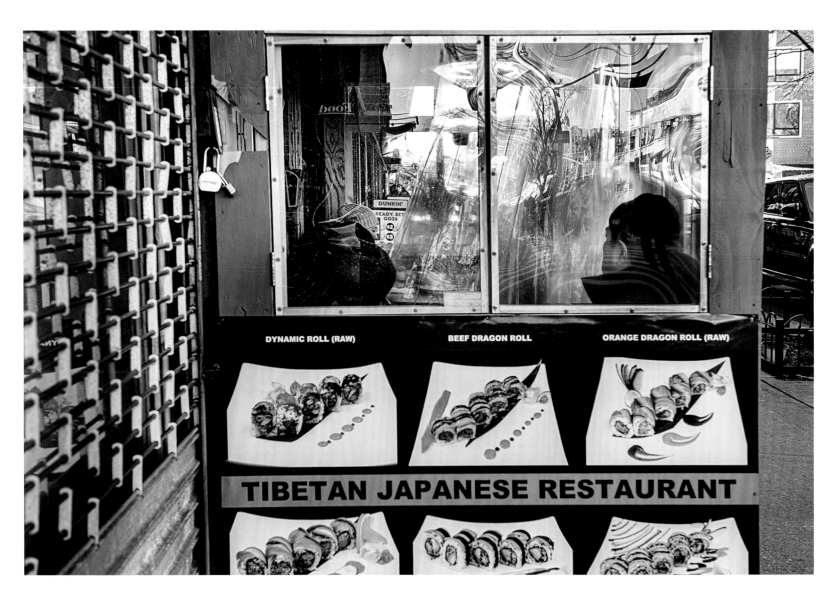

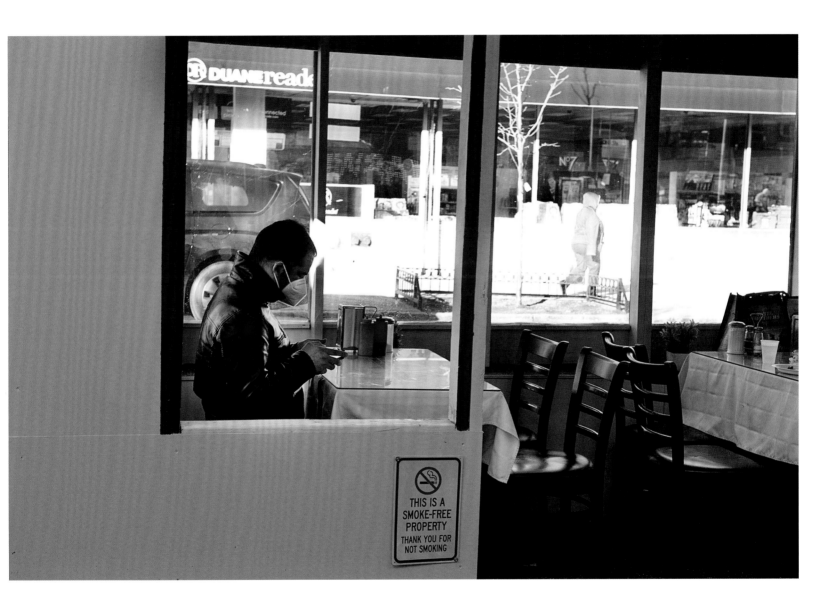

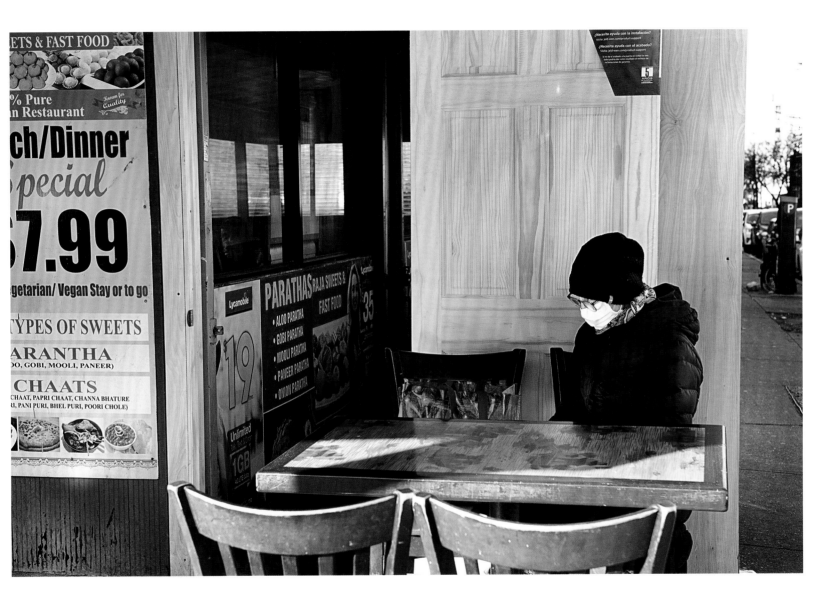

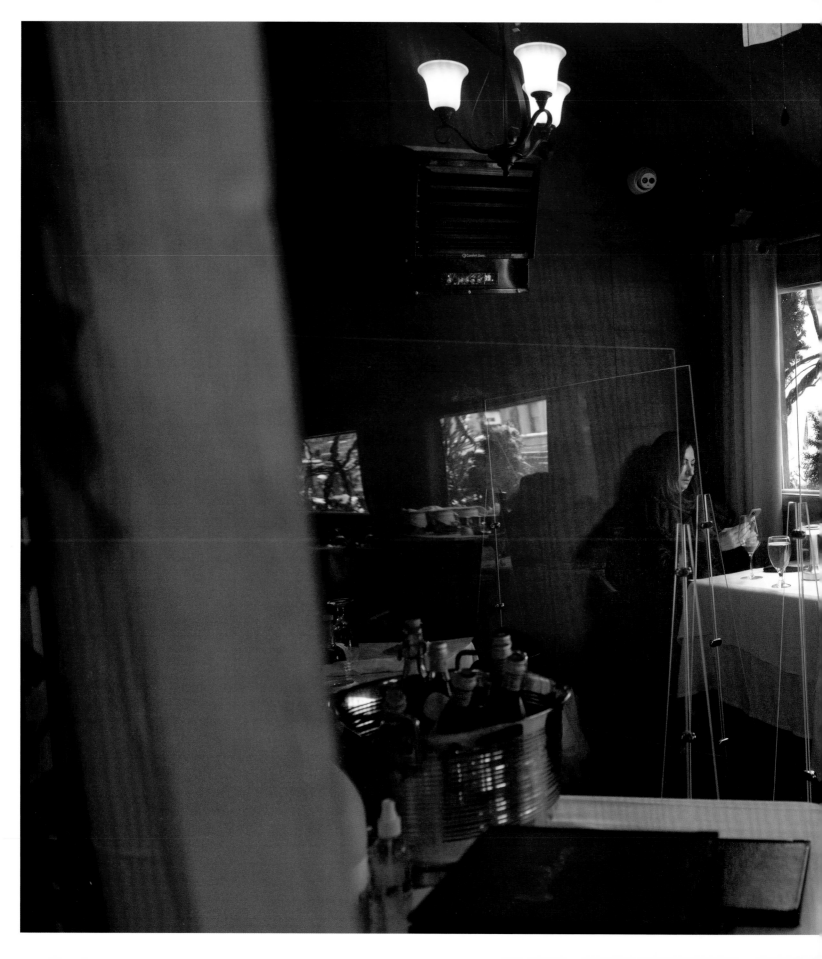

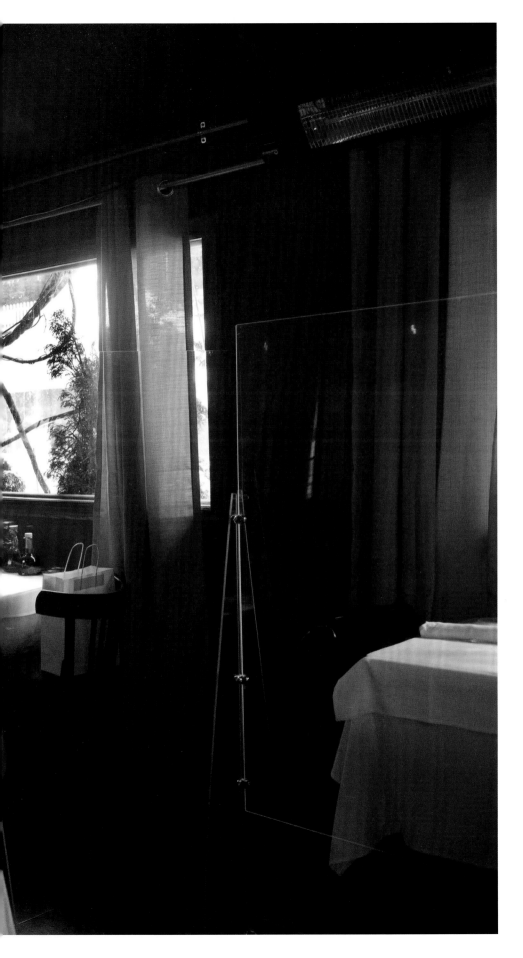

AFTERWORD

Nancy A. Scherl

When we dine alone in public, we are observers, and we are observed. We project our own psyches onto strangers we see in public, but we cannot presume to know with accuracy what they think or what their circumstances are. We cannot easily determine whether those we view for a few moments are, in fact, lonely or at peace in their solitude, whether the person is bound in their aloneness or set free.

Since I first read *The Handmaid's Tale* by Margaret Atwood in the 1980s, I have reread it and watched the television series. The images and concepts of this fictitious tale continue to have a profound effect on me. In both a personal and a political sense, I am terrified of authoritarian behavior.

The allegorical force in the self-portrait included in this book imparts the impression that when I dine alone, I often do intensely explore my thoughts and emotions, and the point of view I formulate is distinctly and powerfully my own. I am enjoined to confront my fears, my concerns, and I am liberated.

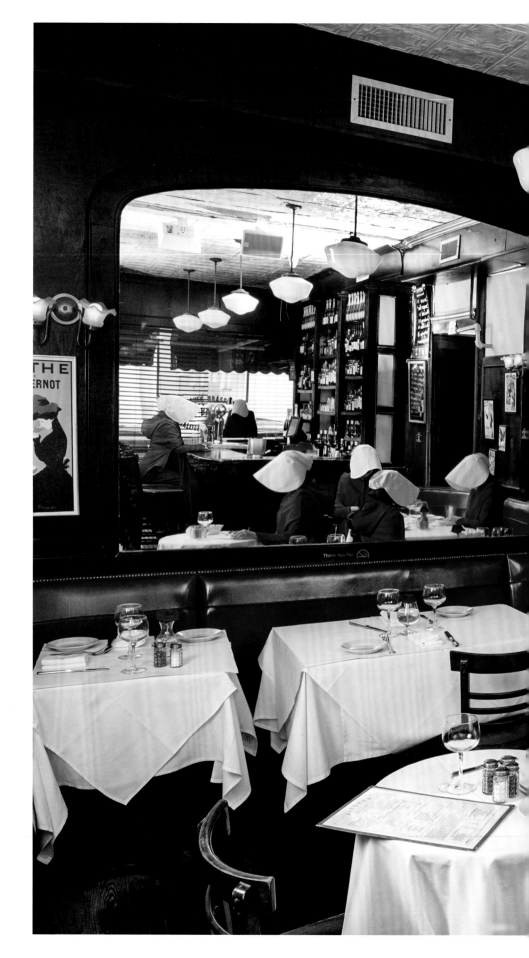

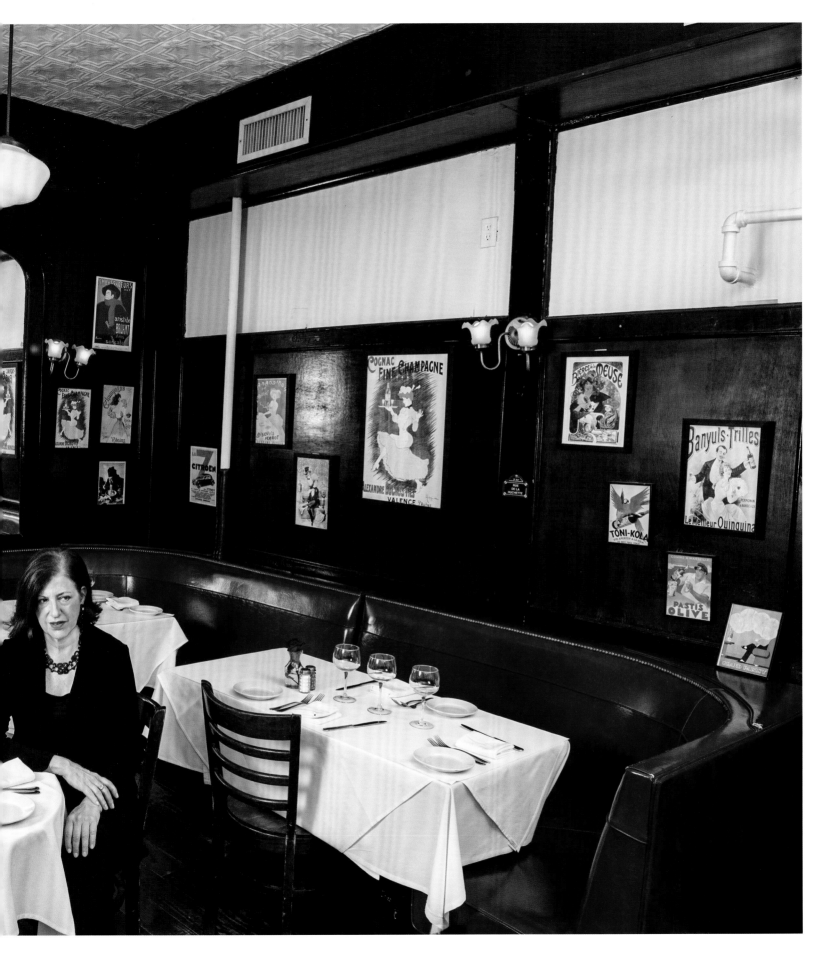

PLATE LIST

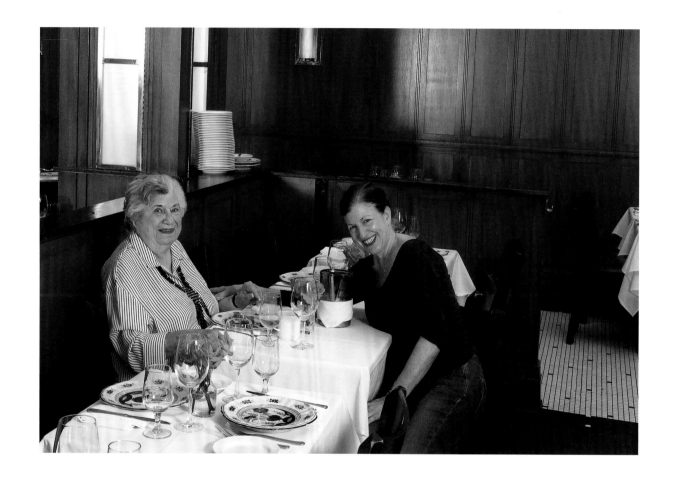

DEDICATION

For My Mother, Lila L. Scherl

I dedicate this book to my mother, for her influence on me as a beacon of strength, a creative and forward-thinking person who loves people. My mother's optimism, enthusiasm, and courageous outlook influenced me as a teenager when she lost her husband, my father. My parents were very social, with many friends. My tightly knit family traveled together and celebrated casual and formal events frequently, so I was afraid of what the future would be for us when I set off for college so soon after my father's death. With the loss of my father, what would life become?

My mother's attitude and outlook prevailed, so our family learned that life does go on, as we celebrated new experiences together and maintained our traditions. Lila returned to school, became an elementary school teacher, continued her social connections with family and friends, and forged new relationships. She both traveled and maintained our holiday traditions, including continuing to host Thanksgiving another forty years with more than twenty family members and friends attending. My mother demonstrated what making peace with being on her own meant. I learned from her not only that life carries on and people can adapt to unexpected circumstances, but also that valuable growth can happen in alone times, including the benefit gained from facing one's self in solitude.

Following college, when I moved back to New York City, my own social world narrowed. My closest friends were married or had continued on to graduate school, but I wanted to pursue my dream of becoming a photographer. Drawing from my mother's philosophy, I felt empowered to pursue my ambitions in the photography world and the wide-open potential the profession offers. Starting as a photographer's assistant, I learned to network, introducing myself to other photography professionals. I lived in New York City's West Village, surrounded by cafes and restaurants, where I had no problem dining by myself. I felt strong and independent, with my mother's example of resilience and thriving in solitude as a guiding light.

Life is fluid and each of us is alone at times. From an early age, I had an inner sense of the difference between solitude and loneliness. The complexity of aloneness has piqued my interest in solitude for a very long time. For the images in this book, I learned to follow my camera in capturing the alone emotion we all experience. In this, I celebrate the special experience of being *alone*, the solitude that my mother inspired me to be fearless in embracing.

ACKNOWLEDGMENTS

With the *Dining Alone* project completed, after years in creative production, I have so many people to both thank and appreciate. My parents, first in my life with foundational support and encouragement, have my abounding gratitude: my father, the late Dr. Siegfried Scherl, whose passion for lens-based media and enthusiasm for film and photography inspired me at a very early age, especially when he took portrait shots of my stuffed animals that I staged for him; and my mother, Lila Scherl, whose passion for life and people was her lens for recognizing and nurturing my budding fascination with photography. I am also fortunate that my maternal and paternal grandparents all enjoyed life uniquely, and each shared their particular expression of joie de vivre and experiences with me. I am also grateful for my entire family and for Rich's. A few years after my father passed away, when I was a young photographer with a fire in my belly, intensely observing the people and landscapes of New York City but unsure if I would be able to support myself, my maternal grandfather, Harry J. Lesnick, gave me memorable advice. I asked him if he thought I was on the right path, given how financially erratic a photography freelancer's life can be. He asked me if I loved what I was doing—to which I answered, "I do." Without blinking an eye and looking straight into mine, Grandfather Harry affirmed with conviction, "Then you are on the right path—stay with it." Harry knew the value of persisting in a life vision and finding one's way. He would often say, "Patience, perseverance, and persistence." A child immigrant from Minsk, Russia, Harry was seven when his father died after walking into an elevator shaft in New York City. Harry set a course for his life by working various restaurant jobs while completing his high school and college diplomas. One job at Nedick's, an early twentieth-century fast food restaurant, was his source of financial support while he completed his medical degree at SUNY Downstate Medical School. Harry became a well-respected obstetrician, and I am so fortunate for the example he set.

Bonnie Briant designed *Dining Alone* with a strong and contemporary point of view. She is also enjoyably one of the most flexible and delightful individuals to work with. I have a special appreciation for Elizabeth Avedon, a famously accomplished book and exhibition designer, an independent curator and writer. She also serves as faculty for the BFA in photography and video and MPS in digital photography degrees at the School of Visual Arts in New York. Elizabeth, an enthusiastic advocate for many photographers and for the medium of photography itself, inspires me. Her encouragement for the *Dining Alone* project has been invaluable for several years. Charles Traub, chair of the MFA Photography, Video and Related Media department at the School of Visual Arts, responded enthusiastically and favorably to my *Dining Alone* photographs when I first shared them with him in 1998. I shared the photographic series with him again in 2019, when it was nearly complete, and he encouraged me to present the images in book form. Grahame Weinbren taught me valuably much about video editing and persistently encouraged this project. Ed Bowes from the School of Visual Arts was enthusiastic from the earliest days of this project for the original title, *Dining Alone*. Years after my days at the School of Visual Arts, I decided to add the subtitle

In the Company of Solitude, also the name of the self-portrait included in this series. But *Dining Alone* has been a special title for this project throughout its decades-long development, and I am deeply grateful to everyone at the School of Visual Arts for their recognition of this work.

Thank you to all contributing editors, writers, and advisors who helped me with this book: Kirsty Seymour-Ure, for her keen insights in preparing this project for publishing, and Laura Pressley—I am profoundly touched and grateful for the beautiful essay she wrote. Thank you to Sherry Edwards, copy editor for this book, also a trusted friend. She has been instrumental in helping me select the appropriate words for my visual story. Thank you to the cofounders at Daylight Books: Taj Forer and Michael Itkoff. I'm grateful to the Daylight staff: Ursula Damm, creative director; Sam Darby; and Gabi Fastman. Thank you to Nancy Wolff, partner at Cowan, Debaets, Abrahams & Sheppard LLP, for her strong support for photographers and publishers and her passion for our industry at large.

I am grateful to Paula Tognarelli, emeritus executive director and curator at the Griffin Museum of Photography, for her attentive review of my work, which she was enthusiastic about. Paula strongly supports the photography community, and I am a grateful beneficiary of her commitment to the photographic arts. Thank you to Crista Dix, executive director of the Griffin Museum of Photography for her advocacy and recognition of this work. A special thank you to all my colleagues at Photolucida 2019, where my *Dining Alone* work was well received during the numerous portfolio reviews, and at the Artist's Walk at the Portland Art Museum in Oregon. The expressed encouragement and enthusiasm from numerous people, including reviewers as well as friends, fired up an incentive in me to see the *Dining Alone* project through to publication. Among the very long list, special thanks to: Laura Moya, Audra Osborne, Mary Bisbee-Beek, Mary Virginia Swanson, and Carsen Sanders.

I am especially grateful to everyone who allowed me to photograph them and to the restaurant managers and owners who allowed me to photograph on their premises; I humbly thank you. Whether you are a friend or someone I serendipitously met, I am forever grateful for your gracious willingness to pose for me or provide the space for capturing a visual moment in time. The culture of *Dining Alone* is enriched by the culture of the restaurant business. The psychology of *Dining Alone* is enriched by the subjects who have revealed how they feel when they dine alone.

Saving the best for last, my soulmate, Richard K. Raker, is unconditional in his support and enthusiasm for what must seem at times my obsession with photography. Rich and I met almost twenty years ago, well after I started the *Dining Alone* project. He knew from our beginnings how passionate I am about the work, so when I was inspired by a location or person I noticed, he was always tolerant and supportive of stopping and waiting, even when we traveled, while I explored the picture-taking potential. Rich is my best critic, source of comfort, encouragement, and the love of my life. I am forever grateful to experience life with him.

ABOUT THE ARTIST

Nancy Scherl is a fine art photographer based in New York City. She describes her work as cinematic. Stylistically, Nancy emulates cinema verité, often posing her subjects, offering subtle direction, and asking them to "act out" how they feel while they are posed in a specific setting. The setting is frequently enhanced with formal lighting to create a specific ambience. Nancy's more candid portraits also emulate cinema verité, but here she both blurs the boundaries between pictorial and street genres and draws from Cartier-Bresson's "decisive moment." Her camerawork may include a predetermined background and sometimes controlled lighting, but she will capture her subjects more spontaneously, once they appear within her camera frame. Nancy refers to her reality-based narratives (including the work she creates as series) as Staged Realities, or in the case of her more candid work, Partially Staged Realities.

Nancy also creates fictional narratives, which she refers to as Staged Fantasies. As a provocateur, she lures viewers into her scientifically impossible visual worlds, designed to intrigue viewers into considering anew their formerly trusted points of view and aspects of the human condition.

Nancy completed an MFA in Photography, Video and Related Media at New York City's School of Visual Arts, following her undergraduate studies in documentary and fine art photography at the University of Wisconsin-Madison. She is a member of the American Society of Media Photographers, where she served as a board member from 2016 to 2019, and currently serves as president on the board of the Katonah Museum Artists' Association (KMAA) in Katonah, New York.

Among other honors, Nancy's work earned a place in the 2021 Worldwide Photography Gala Awards' 16th Julia Margaret Cameron Awards (JMCA) and Photolucida's 2018 Critical Mass Top 200. She received two first-place awards in the 2016 Moscow International Foto Awards and a bronze award in the 2016 Tokyo International Foto Awards. Her work has appeared in numerous shows, including the A Smith Gallery *Portraits* exhibition in 2020; South x Southeast 2020's *Photogallery*; the Katonah Museum of Art's Tri-State Juried Exhibition *Signals* in Katonah, New York, in 2018; and the Katonah Museum Artists' Association juried show *Time and Place* at the Hammond Museum in North Salem, New York, in 2015.

For additional details visit www.nancyascherlfineart.com.

Cofounders: Taj Forer and Michael Itkoff
Creative Director: Ursula Damm
Copy Editor: Gabrielle Fastman

© 2022 Daylight Community Arts Foundation

Photographs © 1985–2021 by Nancy A. Scherl

Foreword © 2021 Laura Pressley
Part I: Universal and Timeless © 2020 by Nancy A. Scherl
Part II: Universal and Timely © 2020 by Nancy A. Scherl
Afterword © 2020 by Nancy A. Scherl
Dedication © 2020 by Nancy A. Scherl

Contributors:
Elizabeth Avedon, picture editor & sequencing
Bonnie Briant, design
Sherry Edwards, copy editor

ISBN: 978-1-954119-14-7

Printed by Ofset Yapimevi, Turkey

Daylight Books
E-mail: info@daylightbooks.org
Web: www.daylightbooks.org